D1582051

Designing Typefaces

David Earls

To Mum, Doug and Scut

In order of appearance

A typeface is not merely a representation of the Roman alphabet. It is the combination of thousands of years of collective human social, technological and economic history, combined with the passion, skill, experience and personal history of its often lone creator.

The Phoenicians are widely believed to have created the basis for the Roman alphabet we know and use today. Thousands of years after their culture died out, their history has survived, visible in every newspaper, computer, television, book and publication that contains that alphabet. For example, it is believed that the letter 'A', the first letter of our modern alphabet, was originally derived from their representation of an ox's head. Oxen were very important in the lives and culture of the Phoenicians, who used them to plough fields, harvest crops and haul wares to markets. As such, they represented a vitally important element in their lives.

Social issues continue to affect typography. This may be on a small scale where design styles arise from political, social and economic change – be it the bell-bottomed type of the late '60s or the rough anarchic 'anti' graphic design in the blossoming of the punk movement of the late '70s and early '80s; or on a larger scale, where events cause wholesale replacement of alphabets, as seen in recent years in Azerbaijan.

Society's social influence on typeface design could easily fill several books. Technology, too, plays an important part. The chisel of a Roman stone cutter formed serifs not because it aided readability or was part of the history of the glyphs themselves, but because it was a necessity of the stone-carving craft – it served as a neat way of ending a carved line.

How glyphs were constructed in the days of handwritten manuscripts of the monasteries of medieval Europe again had as much to do with the qualities of the quill as the aesthetics and visual culture of the time.

In modern times, computer technology has done much to free us from the constraints of even recent history, and certainly in the lifetimes of many of those featured in this book. Armed with a modern desktop computer and font-editing package, we are all free to experiment with typography without

Designing Typefaces

David Earls

RotoVision

A RotoVision book
Published and distributed by RotoVision SA
Route Suisse 9, CH-1295 Mies, Switzerland

RotoVision SA, Sales & Production Office
Sheridan House, 112/116A Western Road
Hove, East Sussex BN3 1DD, UK

T +44 (0)1273 727 268
F +44 (0)1273 727 269
E sales@rotovision.com
www.rotovision.com

10 9 8 7 6 5 4 3 2 1
ISBN 2-88046-699-7

Book design: Bikini Atoll
Photography: Lee Funnell and Xavier Young

Editor: Kate Noël-Paton

Production and separations in Singapore by
ProVision Pte. Ltd
T +65 6334 7720
F +65 6334 7721

the limitations that those who came before us faced. With this new freedom and accessibility, it is possibly this individual perspective which is the most important. Let us take a brief example.

A Catholic high school in a small city in South Wales once had a student in the latter half of the 1980s who had, it later transpires, a mild form of dyslexia. As a result of this, he had terrible, scrawling, cursive handwriting, and one of his many frustrated teachers decided to ban him from cursive writing, only accepting individually formed glyphs in assignments. A few months later this student discovered a solitary Apple Mac and laser printer in the corner of the computer lab. Fascinated by the amazing quality of the printouts, and after many weeks of persuading and pleading with those in charge of it, he finally got to play with it one lunchtime.

On it, he discovered a now long gone package called 'Ready, Set, Go', an early example of desktop publishing software. After a few more lunchtimes of playing, the student started handing in his assignments in laser print, not pen ink. Two years later he was spending more time designing the covers of his assignments and worrying about the finer points of spacing the body copy than writing the words in the first place. Five years on, he was tentatively experimenting with his own typefaces in Art School.

Now, that student is sat at his Apple Mac, typing these words. Would my fascination with typography and type design have been sparked if it were not for that teacher focusing my mind so clearly on my own inability to create written communication by hand? Perhaps. It does, however, illustrate a point that typeface design is as much about the creator as the typeface itself; so much time and effort is involved in the creation of a family of faces that it is foolish to think that it cannot be inextricably linked to the designer. My personal history shapes my own approach to design – I tend to focus on readability. The same cannot be said for, to pluck a random example, aspects of Neville Brody's approach to typography.

Throughout this book, the designers have given their own unique perspectives on type design. Some are contradictory to each other, but each is

heartfelt and right for that person. All are equally valid, as is proven by their personal successes. Those conflicting voices in the texts are a testimony to the simple fact that, like many creative endeavours, the type design process is a deeply personal and subjective activity – not everyone agrees on what is the 'proper' way to do things. The likes of Jonathan Barnbrook usually start on paper, while others, such as Zuzana Licko, work exclusively on computer. Some, like Erik van Blokland and Just van Rossum, will collaborate on projects, while others prefer to work alone. Rian Hughes prefers to keep his families small, often concentrating on display typefaces. Others spend year after year perfecting and enlarging their families into comprehensive works that can be applied to the most challenging of typesetting applications. A typical example is Jeremy Tankard's Bliss; a typeface family that has taken over a decade to develop, it currently consists of over 160 typefaces.

How they approach typography will, inevitably, be different to you – if it were not, there would not be tens of thousands of typefaces available for Mac or PC. The aim of this book is to bring together a wide variety of different designers from around the globe, and find out about their lives and work, in order to build up a picture of the type design community and its processes. Each designer, due to their own particular pasts, interests, skills, personalities and even politics, brings to the book their own focus and areas of expertise. The end result is a comprehensive examination of the whole type design process.

The final section of the book brings together some of the more practical advice from the designers on how to actually get started yourself. The tutorial aims to provide enough grounding in the whole process from start to finish to get you off to a flying start. As far as is practically possible, the skills and advice contained within are not tool-specific or platform-specific – it is hands-on and immensely practical in its scope, but you are the one in the driving seat.

What this book is not, is a step-by-step manual. It is here to inspire you to find out more and experiment for yourself, to help foster a passion for typography and a respect for the craft and profession of type design. Learn from the designers, their opinions and methods, and use those which suit you as a designer.

A few words of warning to you. Typeface design is neither easy or quick. To create typefaces of value and quality requires time, effort, skill and above all, patience. Be inspired, be eager, enjoy yourself, but remember that the alphabet you are working with has taken thousands of years to develop to its current state. Respect that history, learn from the past, and give yourself and your work the time it deserves to succeed. To do otherwise is a recipe for disaster.

Good luck, and happy designing!

Designer profiles

Jonathan Hoefler

A self-proclaimed 'armchair type historian', Jonathan Hoefler is well known not just for the excellent quality of his typeface designs, but also for his understanding of the historical context in which those designs rest.

Born in 1970 into the creative hub that is New York, Hoefler has spent his life interested in type – from childhood, when he would play with Presstype, through to high school when his awareness of typography grew as he was exposed to the work of Fred Woodward in *Rolling Stone*, *Spy Magazine* and others. Rather than take the traditional route into design by going to art college, Hoefler went straight into the world of work, initially as a graphic designer.

He found, however, that the world of graphic design could not offer him sufficient typographic stimulation, either in terms of type research or in writing – both activities he is deeply passionate about. In creating his own foundry – the Hoefler Type Foundry – he has been able to marry this fascination with the history of the craft with the creativity of developing new typefaces.

His work has included typefaces for the magazines *Rolling Stone* (The Proteus Project) and *Sports Illustrated* (the Champion Gothic family), and for the company Apple Computer (the Hoefler Text family). He has also revived several, including HTF Didot (based on the work of the French type founder, Firmin Didot).

Given his interest and knowledge of the historical aspects of type design, I asked him if, as a designer, he ever felt that this knowledge and understanding of historical work could be seen as a double-edged sword. Having a clear understanding of the problems faced and how those before us solved them can help, but it might prejudice our work and inhibit new, creative solutions to problems. He responded:

"I do think it's possible to be inspired by history without being hidebound to tradition. As you say, it's useful to see how others solved familiar problems, and one of the maddening things about typography is that so many seemingly new problems have already been addressed, though sometimes obliquely. Analysing the historical record is also a useful way to find new challenges: there are still a lot of gaps to be filled,

and there are plenty of opportunities to complete unfinished experiments or solve unsolved equations. As far as I'm concerned, things as pedestrian as 'how do you create a boldface Old Style?' or 'what kind of italic should a Venetian have?' are still open and valid questions. The joy of typography is that it is inherently experimental, and plenty of experiments that failed early on are still worth re-enacting. There are hybrid serif/sans serif fonts from the 1880s, an aesthetic that wasn't further explored for another 110 years.

"When I was working on The Proteus Project, I spent a lot of time looking at Regency and Victorian display types, and collecting loose ends that seemed worth tying up. Why did slab serif 'egyptians' and sans serif 'grotesques' deserve matching italics, but not wedge serifed 'latins' or chamfered 'grecians'? Answering these questions required stepping off the historical path without losing sight of traditional letterforms, and the solutions often required synthesizing something out of two seemingly contrary approaches to type design.

"Right now, I'm mulling over a set of six blackletter initials that Caslon Junior left us, wondering if I'm properly interpreting what I think might be an interesting thesis. Whether or not I'm able to understand his intentions may in the end be irrelevant, since my goal is just to create a worthwhile typeface, but I think this means of arriving at the destination is a productive and interesting one."

In the past Hoefler has dismissed the suggestion that his work be described as classical, preferring it instead to be described as experimental. His work, such as that on HTF Gestalt certainly gives credence to this assertion: an intelligent, witty typeface, it was constructed in such a way as to only become legible within the context of a sentence, rather than each individual glyph necessarily being readily identifiable in its own right.

Hoefler Text is another experimental face, but this time in terms of technology. It was originally commissioned by Apple to demonstrate the flexibility of its QuickDraw GX font technology (now defunct), which allowed for vastly extended character sets including swashes, extended sets of ligatures, ornaments, and so on.

His family, Hoefler Titling, was released as a display counterpart to Hoefler Text, the typeface he created for Apple. Hoefler Titling was created from scratch, however, rather than being based on the forms of Hoefler Text. I asked Jonathan about the reasons behind this:

"Hoefler Titling began as a deeper exploration of some of the historical material I'd looked at for Hoefler Text. Hoefler Text was inspired most directly by two hot-metal designs, Linotype Garamond No.3 and Linotype Janson Text 55. Both of these are really secondary sources, interpretations of more noteworthy historical types – in this case, the seventeenth-century work of Jean Jannon (who was mistaken for Garamond) and Nicholas Kis (who was mistaken for Janson).

"I didn't set out to create a counterpart for Hoefler Text, as much as I just wanted another chance to immerse myself in the baroque. My early drawings for Hoefler Titling seemed better suited to display sizes than text – the design's long ascenders seem to single it out for bigness – and I was pleased with the way this new font worked with Hoefler Text, provided I relegated that design to small sizes. (Hoefler Text is full of things that are easier to forgive at nine point than at 72.) Since I was developing the new font as an autonomous family, I didn't feel particularly constrained by the forms of Hoefler Text. I just presumed that since both fonts had been marinated in the same historical broth, they'd ultimately have some affinity for one another."

So much of Hoefler's work has been influenced and informed by metal-founded type, that I wanted to know if he felt that modern, clinically-precise digital revivals can ever hope to recapture any of the warmth that's often attributed to metal type:

"I think so. One of the amazing things about type is just how many different strategies a designer can use to achieve the same goal. It's not hard to evoke the warmth of foundry type in very superficial ways – bumpy edges, erratic baselines, and all that – and the results are often surprisingly effective. Years ago I tried auto-tracing the seventeenth century 'Fell Types' as a demonstration of why you shouldn't slavishly ape an original source, and much to my horror the results were kind of nice.

In a subsequent experiment, I tried comparing my warts-and-all digitisation to a more abstracted revival, in which the rocky curves were replaced by smooth ones and the serifs were pruned to less rakish angles. The point was to demonstrate that the beauty of foundry type is the sum of its shortcomings, but once again I was surprised: this time, the 'clean' version lost none of the warmth of the original. I think this must prove that the virtues of a good typeface are more than skin-deep.

"When I first got involved in typography professionally, I was quick to seize on the easy strategies for making typefaces feel less digital. This was in 1988, when Robert Slimbach's Adobe Garamond felt like a brilliant riposte to the proudly digital work that Zuzana Lîcko was doing at Emigre, which I was trying not to imitate. Robert is especially good at bending the medium to his aesthetic, and I admired the ways in which Adobe Garamond concealed its bezier points beneath bowed serifs and rounded corners. In many ways, Hoefler Text was my exuberant jump into this pool; I wanted to create a typeface that didn't feel like a digital font. At the time, I felt that straight lines meant digital, and digital meant cold, which was a bit of an oversimplification.

"In subsequent years I've changed my mind about this, noticing how many of my favourite fonts – how many truly warm designs – are unfailingly digital. Matthew Carter's 'Galliard' and 'Miller' come straight to mind, along with Bram de Does' 'Lexicon' – each of these faces is a riot of sharp corners and parallel lines, and yet somehow they manage to have all the warmth of the best foundry types. Hoefler Titling, which I began in 1994 and finally wrapped up this year, is probably the last stop for me on the soft-and-rounded trajectory; I'm really interested now in seeing how the digital aesthetic and the appeal of traditional typography can be simultaneously embraced."

ABCDEFGHIJKLMNOPQRSTVWXYZ
ÆŒÀÁÂÄÃÅÇÈÉÊËÌÍÏÎÑÒÓÔÖØÙÚÛÜŸ

ABCDEFGHIJKLMNOPQRSTUVWXYZ@
Æ Œ FI FL SS ÀÁÂÄÃÅ ÇÈ É Ê Ë Ì Í Î Ï Ñ Ò Ó Ô Ö Õ Ø Ù Ú Û Ü Ÿ
& # $ 0123456789 ¢ £ ¥ % ‰ + = { ([]) } * ¶ † ƒ
© ® ™ a o , . … : ; ¿ ? ¡ ! _ ' " " " ' ' „ / • - – —

ABCDEFGHIJKLMNOPQRSTVWXYZ
ÆŒÀÁÂÄÃÅÇÈÉÊËÌÍÏÎÑÒÓÔÖØÙÚÛÜŸ
ABCDEFGHIJKLMNOPQRSTUVWXYZ@
Æ Œ ÀÁÂÄÃÅ ÇÈÉÊË ÌÍÎÏÑÒÓÔÖÕØÙÚÛÜŸ
& # $ 0123456789 ¢ £ ¥ % ‰ + = { ([]) } * ¶ † ƒ
© ® ™ , . … : ; ¿ ? ¡ ! _ ' " " " ' ' „ / • - – —

ABCDEFGHIJKLMNOPQRSTVWXYZ
ÆŒÀÁÂÄÃÅÇÈÉÊËÌÍÏÎÑÒÓÔÖØÙÚÛÜŸ
abcdefghijklmnopqrstuvwxyz@
æœfiflßàáâäãåçèéêëìíîïñòóôöõøùúûüÿ
*& # $ 0123456789 ¢ £ ¥ % ‰ + = { ([]) } * ¶ † ƒ*
© ® ™ a o , . … : ; ¿ ? ¡ ! _ ' " " " ' ' „ / • - – —

2.

1. Hoefler Titling typeface family, 2002

 Hoefler Titling, as its name suggests, was designed for use above 36pt in titling applications, and was designed as a companion font to the earlier Hoefler Text family. Jonathan Hoefler's great interest in the historical aspects of typography often shows through in his work – just like Hoefler Text, the Hoefler Titling family was greatly influenced by the seventeenth century baroque types of Jean Jannon and Nicholas Kis.

2. Hoefler Text typeface family, 1991–1993

 Originally developed for Apple Computer to demonstrate the power of its now defunct QuickDraw GX font rendering technology, the Hoefler Text family of typefaces spans twenty-seven designs. It was designed from the outset to be a comprehensive family that would be of heavyweight serious typographic use, as it includes not just the standard range of weights, but also small caps and swashes, alternative versions, fleurons, ornaments and even pattern tiles.

2. ABCDEFGHIJKLMNOPQRSTVWXYZ
ÆŒÀÁÂÄÃÅÇÈÉÊËÌÍÏÎÑÒÓÔÖØÙÚÛÜŸ
abcdefghijklmnopqrstuvwxyz@
æœfiflßàáâäãåçèéêë1ìíîïñòóôöõøùúûüÿ
&#$0123456789¢£¥%‰+={([])}*¶†f
©®™ªº,.…:;¿?¡!_'"""''„/•--—

3.

4.

3. *ABCDEFGHIJKLMNOPQRSTVWXYZ*
ÆŒÀÁÂÄÃÅÇÈÉÊËÌÍÏÎÑÒÓÔÖØÙÚÛÜŸ
abcdefghijklmnopqrstuvwxyz@
æœfiflßàáâäãåçèéêëıìíîïñòóôöõøùúûüÿ
&#$0123456789¢£¥%‰+={([])}¶†f*
© ® ™ ᵃ ᵒ, . … : ; ¿ ? ¡ ! _ ' " " " ' ' „ / • - – —

ABCDEFGHIJKLMNOPQRSTVWXYZ
ÆŒÀÁÂÄÃÅÇÈÉÊËÌÍÏÎÑÒÓÔÖØÙÚÛÜŸ
abcdefghijklmnopqrstuvwxyz@
æœfiflßàáâäãåçèéêë1ìíîïñòóôöõøùúûüÿ
&#$0123456789¢£¥%‰ + = {([])}*¶†ƒ
©®™ªº,.…:;¿?¡!_'"""''„/•--—

5.

6. The Hoefler Type
Foundry Catalogue

A catalogue containing type
specimens from the entire
Hoefler Type foundry range,
including designs from
Tobias Frere-Jones, Josh
Darden, Jesse Ragan,
Kevin Dresser as well as
Jonathan Hoefler himself.

Catalogue of Typefaces

Fifth Edition

THE HOEFLER TYPE FOUNDRY | *typography.com*

ad finem effrenata iactabit audacia? Nihil
te nocturum praesidium Palati, nihil urbs

MARCIANO

OBINSON

AD ALI

HTF DIDOT MEDIUM

QUO USQUE TANDEM ABUTERE CA
Quam diu etiam furor iste tuus nos elud
ad finem sese effrenata iactabit audacia
Nihilne te nocturum praesidium Palati,

HTF DIDOT MEDIUM ITALIC

O TEMPORA, O MORES! SENATUS
Quam diu etiam furor iste tuus nos elude
ad finem effrenata iactabit audacia? Nih
te nocturum praesidium Palati, nihil urb

HTF DIDOT BOLD

SENATUS HAEC INTELLEGIT, CON
Quam diu etiam furor iste tuus nos elu
ad finem sese effrenata iactabit audaci

HTF DIDOT BOLD ITALIC

SENATUS HAEC INTELLEGIT, CON
Quem ad finem sese effrenata iactabit?
Nihilne te nocturum praesidium Palati

, acropolis, saracen)
families for just $299 — save $97!

RAT BLACK ITALIC

ORTING

efraction

HAN BLACK ITALIC

BSIDIAN

hinestone

OLIS BLACK ITALIC

Z	Z	Z	Z
LIGHT ROMAN	LIGHT ITALIC	MEDIUM ROMAN	MEDIUM I

ALLSORTS EIGHT FONTS

the fell types (roman, italic, small caps) st. august
english textura (regular + alternate) great primer

8. Well Tempered

9. SERGEI RACHMANINOV

11. *Ernest*

12. *Complete*

Clavier

10.
Russian Easter Overture

Schelling

Violin So

Jonathan Barnbrook

Typeface design is not always about meeting a brief or satisfying commerce's need for consistent global branding – throughout typography's long history, it has contributed to social and political change. In today's type-design community, there can be no greater proponent of the power of typography to convey a political message than Jonathan Barnbrook.

Based in Soho, firmly sandwiched between the brightly lit, commercial hustle and bustle of Piccadilly Circus and the British media industry that is famed for its monetary excesses, the location of his studio seems strangely out of place for the softly spoken but deeply passionate Barnbrook. There, he works on graphic design pieces for clients throughout the world and runs his type foundry, Virus.

He first started creating fonts while at the Royal College of Art back in the late 1980s as a way of better controlling his graphic design pieces:

"To have absolute control, to be able to use the exact contemporary tone of voice, I felt I needed to control the drawing of the font as well. Secondly, I felt that typography was not reflecting what was going on in my life or the way technology was affecting everybody's lives. Yes, the technology was invisibly affecting the methods of using fonts, but more importantly, the computer had completely changed the whole nature of typography and this ideology needed to be expressed in letterform design. I know some typographers will groan to hear me, but you can not turn the clock back and think in a non-political non-fragmentary way (in terms of ideology) about letterforms. This does not mean that I think many of the typefaces drawn using this technology are good – they're not. Just because you can process or filter a typeface on a computer doesn't make it a good idea. You still have to look at some of the basic principles – such as what good drawing is – and have the knowledge to work with or against the history of typography."

This understanding of the historial aspects of typeforms is not purely academic. In 1990, Jonathan created a series of three typographic stone carvings, one of which is now displayed at the V&A Museum in London. Before embarking on the project, he took a traditional stone-carving course to fully understand the basis of serifs in

24

carved letterforms. The final three pieces were created with a modern gravestone carver; 3-D templates are used to trace letterforms with a pantograph device – the pantograph then controls the drill system.

"The pantograph was designed to copy the hand of a mason, but it didn't do it very well because all of the templates were too geometric, resulting in a terrible example of industrial mass-produced copying of a craftsman's visual language. I tried to come up with some contemporary language for stone carving, trying to use the parameters in a positive rather than a negative way to cover up the fact that technology was being used.

"Of course, working on a piece of stone is very different to working on paper or on a computer. Here you have one chance and it lasts forever – grinding down stone is a pretty final way of marking, one that you can never erase. As a result, where mistakes were made, I tried to make them part of the design process. Stone carving, to me, is what the base of typography is – it's about communicating some kind of truth, and when you carve in stone, the message does last forever."

Jonathan's interest in stone carving has been reflected strongly in his previous type designs. His Manson (later renamed by Emigre as Mason), Nylon, Draylon and Exocet typefaces are all strongly based on stone-carved historical forms, for example. He is keen to emphasise the point that good typeface design comes from understanding the history of typefaces:

"Eric Gill drew what I consider to be some of the most beautiful letters. He was a stone carver and drew a lot. I consider drawing very important to be a good type designer – far more important than also being a trendy video director or knowing the latest software. Typography is about fashion, about doing things which are in the spirit of the moment. But that is not all it is about – anybody who wants to be any good has to do it properly and learn how to construct the letter-forms in a traditional way – only then can you understand the parameters of subversion."

His belief in the value of drawing as part of the type design process is put into practice in his own typefaces:

"Usually the typefaces start off as very rough characters drawn in my sketchbook. These are drawn when I am travelling or they can come out through the process of drawing – investigating the ways you can produce the construction of letterforms. Usually I have drawn some of the letters of a typeface thirty or forty times before I start to draw them properly – this gives me a feeling for the letters. These rough sketches are then drawn up on the computer – not traced but referred to – it's then a process of refining it. Working on a computer can be difficult because everything is in sharp black and white; it doesn't often allow you the softness of a rough pencil drawing, so often the work looks terrible with the first printout. But after many hours' refining further it begins to look OK."

His own learning experiences come not from the traditional design education system – which he believes often fails students by not teaching sound, basic typographic principles and knowledge – but rather from his own efforts:

"I learnt partially through instinct and partially through reading books on how to construct letterforms, but mainly from a passion for the history of type. I looked with fascination at the thousands of beautiful examples through the past few millennia of letterform design, absorbed it all, and got to understand proportion, to understand what was a well-drawn letter, to understand all of the different ways and methods of constructing letterforms."

Despite his love and respect for historical typographic forms, Jonathan Barnbrook is not afraid to innovate with experimental typefaces. His recently released typeface, Expletive, an experimental script typeface based on a circle, challenges convention by having individual characters that rise and dip above and below the baseline. Barnbrook is always careful to have a rational basis to his work – he is aiming to experiment and add to the field of typography, not to shock.

"I don't try to be controversial, or shocking. I find that kind of thing rather boring and empty. I just don't think there is a divide between graphic design and the real world. The real world contains death, sex, shit and so on, and this is just reflected in the work."

His typefaces are very much a product of his personal beliefs and observations – so much so that they have been noted in the past for being difficult to use, so entwined are they with his personality:

"It comes through being an artist observing the world and trying to put a bit of that world into my work. Typefaces always speak in a certain voice and I want those voices to be heard – often the process of drawing is just visually conveying that voice you have noticed. Or it can be a need to express a particular voice from inside yourself that you feel needs expressing. When I say 'voice', I mean a particular tone of talking, this is what a typeface does to a particular piece of text.

"First is the craft – to draw the font well and with good proportion. Another thing is to deal with the meaning and transference of that meaning in language. Finally, I have an unease about what typefaces are often used for, which is to lie on behalf of many companies. Of course, I don't have control over how a typeface is used once it is released, but what I want to do is make people realise that typeface design and graphic design are part of the propaganda that many companies put out to produce a good image when they are doing things which cause damage to the environment and much human misery. This unease of mine is often represented in the name: 'Bastard' was for corporate fascists; 'Nixon' was for telling lies with; 'Drone' was for text without content."

Barnbrook is not afraid to be open with his beliefs and live by the consequences. His recent work on the republishing of the First Things First manifesto, and his design work for Adbusters (www.adbusters.org/) speaks of a man who is willing to do more than just spout hyperbole – his time and talent have been given free of charge to support the message:

"I'm never really motivated by money, and I've put a lot of energy into working with them. It's good because you feel there is a chance to make a difference."

His admirable conviction leads him to turn down lucrative work if the companies involved do not meet his ethical standards. He attributes his political nature to his background and the nature of typography itself:

"It's probably to do with having a working-class background and caring a lot about typography and the meaning of the words conveyed in the typography. Typography has always been political – printed words are one of the most effective forms of propaganda. That is why the first examples of typography in the West were Bibles – the Christian church saw it as the best way to distribute their propaganda. I would like to answer the many designers who ask me, 'why is your typography so political?' with the question – 'Why doesn't your work relate to the world outside design and outside your studio?'"

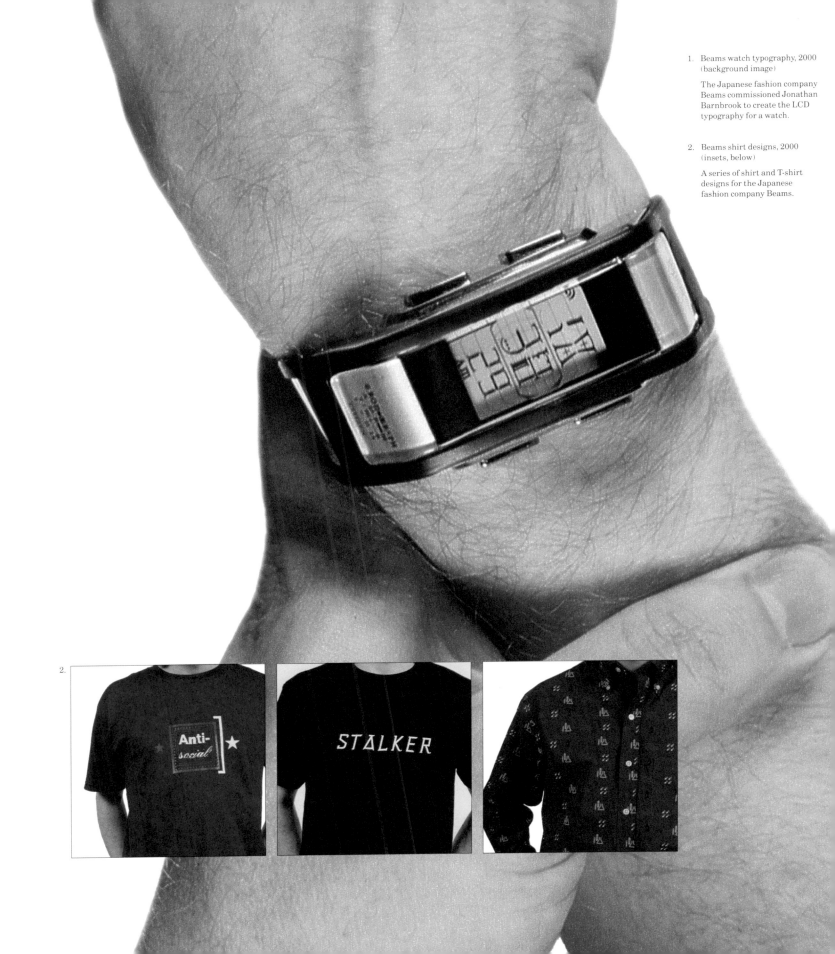

1. Beams watch typography, 2000
 (background image)

 The Japanese fashion company
 Beams commissioned Jonathan
 Barnbrook to create the LCD
 typography for a watch.

2. Beams shirt designs, 2000
 (insets, below)

 A series of shirt and T-shirt
 designs for the Japanese
 fashion company Beams.

TE·CH·NO·LO·GY

IS ~~NOTHING MORE~~

NOTHING MORE

~~THAN~~

NOT PROCESS

AN END IN ITSELF

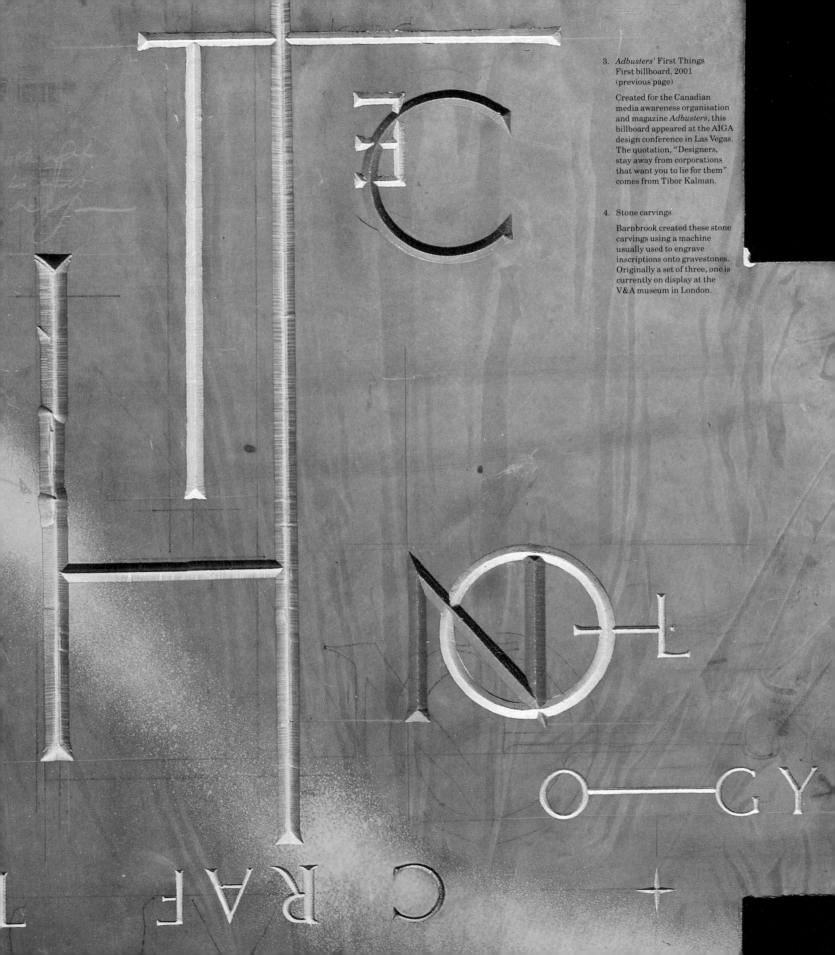

3. *Adbusters'* First Things
 First billboard, 2001
 (previous page)

 Created for the Canadian
 media awareness organisation
 and magazine *Adbusters*, this
 billboard appeared at the AIGA
 design conference in Las Vegas.
 The quotation, "Designers,
 stay away from corporations
 that want you to lie for them"
 comes from Tibor Kalman.

4. Stone carvings

 Barnbrook created these stone
 carvings using a machine
 usually used to engrave
 inscriptions onto gravestones.
 Originally a set of three, one is
 currently on display at the
 V&A museum in London.

Melancholia

6.

NEWSPEAK

NEWSPEAK

5. Damien Hirst monograph
*I want to spend the rest of my
life everywhere, with everyone,
one to one, always, forever,
now.* 1997 (insets)

Jonathan Barnbrook's book
designs for fine artist Damien
Hirst's first monograph were
designed to break away from
the traditional art book model.
Working closely together,
Barnbrook and Hirst
produced a piece that
attempts to bring alive Hirst's
work in an innovative and fun
manner. The book includes
pop-ups, fold-outs and
even stickers.

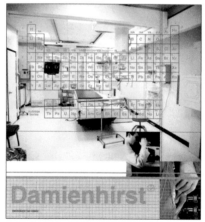

Damienhirst

5.

"there is a dream that is apparently
widespread among forensic
pathologists–the death dissectors,
the gore explorers, the rummagers
in the tossed away envelope of the
soul, up to their elbows in it. the
autopter is performing an autopsy
on a member of his family. he has
taken out the organs, can't get
them back in again, but must keep
sewing up the body–which is alive,
though dead–by day. the harder
he labours with the viscera, the
more panicked he becomes, the
more insistently they slop out

again... hearing about the dream
i of course immediately thought
of damien, who at this point is up
to his neck in it.

'let's go in'. it's interesting that
surgeons and safe-blowers, in
their popular portrayals at least,
use the same expression to
inaugurate their precise,
premeditated, violently invasive
procedures: the alarm hardware
decommissioned and mute; the
human wetware morphised and
sundered (inverted, divided)."

gordon burn, 1993

10.

DRAYLON
NYLON

Melancholia Alternate

Italic

elancholia Regular _{7.}

6. Newspeak typeface family,
 1999 (top left)

 Based on the letterforms in
 Stalinist Russia, and named
 after the language featured in
 George Orwell's novel, *1984*.

7. Melancholia typeface family,
 2002 (top right)

 A delicate sans serif typeface
 that, unusually, makes use of
 swash characters. The italics
 are true italics, rather than
 sloped Roman versions.

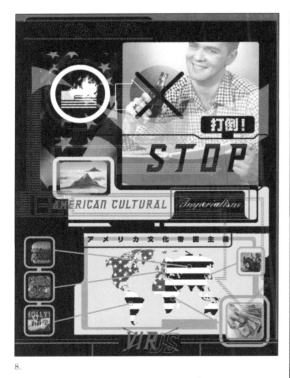

8.

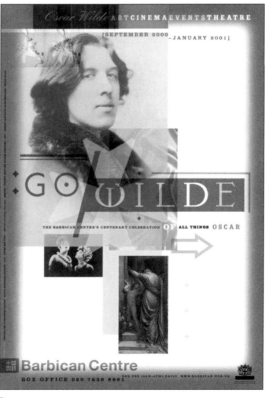

9.

8. Japanese Virus poster, 2000

 Created for the Japanese
 release of Virus fonts,
 Barnbrook used the poster
 as an opportunity to make
 a political commentary on
 American cultural imperialism.

9. Oscar Wilde poster, 2000

 A poster designed for the
 Barbican Centre in London's
 Oscar Wilde series of events.

10. Draylon and Nylon typeface
 families, 1997 (bottom left)

 These two families are distinct
 from one another in their
 varying influences; Nylon
 was influenced by painted
 letterforms from the thirteenth
 to the sixteenth centuries,
 Draylon by the more restrained
 forms of the seventeenth and
 eighteenth centuries. However,
 they have been designed in
 such a way as to be usable
 together in the same word.

Akira Kobayashi

This book's focus is on typographic design in relation to the Roman alphabet. As such, it is hardly surprising that the majority of the contributors are from those Western nations in the Americas and Europe that use that alphabet. Yet one of the most interesting contributors to the field of modern typography is a designer raised in Japan – a country with a visual culture and writing system far removed from its occidental contemporaries.

Born in 1960, Akira Kobayashi studied at Musashino Art Universty in Tokyo until 1983, before starting work as a designer for Sha-Ken Co, Ltd, a phototypesetting equipment manufacturer. He told me about that first job, and his transition from designing Japanese characters to creating Roman (or Latin) typefaces:

"As you may know, a complete Japanese font requires approximately 7000 characters – too much for a single type designer to complete. Designing a Japanese font usually takes a couple of years and several skilled designers. I was involved in several projects of Japanese fonts and I gradually improved my skill in drawing lines with a pointed brush.

"Occasionally I designed Latin characters and arabic numerals as I felt that I needed to learn more about Latin alphabets. I quickly realised that I had to have a far better understanding of the English language. Firstly, the books available to me on the Latin alphabet were almost always written in English. Secondly, I knew that if I was not very familiar with the Western alphabet, I could not know if the characters I drew would be acceptable to a Western reader."

His quest started with Hermann Zapf's book *About Alphabets* and Edward Johnston's book *Writing & Illuminating & Lettering*, fuelling a passion for calligraphy that eventually led him to move to London to attend a calligraphy course at the London College of Printing and continue his study of English.

I asked him about his first Roman alphabet creations:

"I decided to design my own Latin typefaces because my first impressions of digital type were not good. I remember very clearly when I first used a digital version of the Bembo typeface. I had never touched

"Sometimes it seems that I spend more time worrying about white space than I do designing the letterforms."

a computer until I worked for Jiyu-Kobo, a type design studio in Tokyo, in 1991, right after I came back from London. The studio bought type design software from a European company which offered ten digital fonts from their library. I was responsible for choosing the fonts, and my selection included Bembo, Bembo Italic and Bembo Bold. On their arrival, I immediately opened Bembo Roman with the type design software. The Font layout appeared, and I double-clicked the lowercase 'g' just to check if the software was working correctly. After seeing the letter 'g' about ten-inches high, I immediately thought I had made a mistake, because it did not look like a Bembo 'g'. After seeing the 'a', and another letter, I got into a slight panic – none of the letters looked like Bembo!

"After checking Bembo Italic, I slowly began to realise that the fonts were indeed Bembo. I recalled that the typeface was originally designed for metal type, and most of the specimens and texts I saw were set in metal type in text size. I knew that a metal typeface was cut or designed separately for each size, but that a film composition or digital typeface is a kind of compromise since it has proportions designed for reduction and enlargement. I was overwhelmed to see such a huge gap.

"After examining Western specimens using Bembo, I felt the types that were originally designed for hot-metal often looked too light and feeble. I purchased digital rendering of classic text types, but again they did not quite satisfy me. This led me to begin thinking about designing a new, digital, Latin typeface, and this was how I started FF Clifford, the first Roman text type I designed for use in Western countries."

Since that time he has been prolific as a typeface designer, releasing typefaces for a wide variety of both large and small foundries, including Letraset (Skid Row), ITC (Scarborough, Japanese Garden, Woodland, Seven Treasures, Luna, Vineyard, Magnifico and Silvermoon), Linotype (Conrad), TypeBank (the Mincho series of families, Gothic, Maru Gothic, Calligra Gothic), FontFont (the Acanthus families, Clifford), Adobe (Calcite Pro) and TypeBox (Lithium).

Akira Kobayashi is unusual in being the only designer in this book who has not started his own foundry – he prefers to stick solely to design and avoid the stresses involved in running a business. As he puts it himself, "I would rather concentrate on designing types than doing paperwork, dealing with taxes and legal issues." He is currently based in Germany as the Type Director of the Linotype Library. His role there affords him the opportunity to continue his creative work (he is currently working on a redesign of Optima with Hermann Zapf and others), while maintaining the aesthetic quality of in-house and submitted designs for the foundry as a whole.

Talking of his own work, Akira told me that he draws inspiration from a wide variety of areas, from historical type specimens and lead type through to 'Yose-moji', a type of Japanese calligraphy used for comedy playhouse billboards, which he studied for many years. I asked him how he approaches the design of his typefaces:

"I always draw sketches on paper; usually ten to twenty characters are drawn by hand and the rest are designed on screen. The drawings are sometimes scanned and traced by hand; sometimes they are not scanned and in that case, I design directly on screen with my sketches alongside.

"When I am more or less satisfied with each letter, the most important and stimulating step begins – character spacing. The success or failure of a type is a question of a good balance of white space inside and outside the letters.

"Then, the kerning: when the letters are grouped together in the form of words, certain combinations of letters may appear awkward [such as the space caused by an uppercase 'A' followed by a lowercase 'v' – Earls]. The kerning is a solution, and a decent text typeface will typically have hundreds of kerning pairs in the font data. This has to be done manually because kerning is a matter of appearance. To achieve this balance in my work I spend large amounts of time checking and adjusting the white space between letters. Sometimes it seems that I spend more time worrying about white space than I do designing the letterforms.

"The next step is proofing. I set a text block in English, German, French and Spanish, and check all the word-shapes. It would probably help if I could read all these languages, but I still get a good idea of how the design balances out. This process is usually repeated several times."

I finished our discussion by asking Akira whether he feels that being brought up with the Japanese writing system has affected his approach to Roman typeface design:

"We are taught the Western alphabet and English language at the age of ten, so Latin alphabets do not appear too exotic to us. More and more Japanese graphic designers tend to design logotypes and posters with Latin alphabets, and interesting logos and display types have been designed by Japanese designers. However, it does seem difficult for us to design a decent Latin typeface.

"Our writing system is completely different from the Western one – a Kanji or Chinese character is a 'word' by itself. We also design Japanese characters in a complete square, because they can be set either vertically or horizontally. Because of that, most Japanese graphic designers think that a foreign word or words can be read if they can be read letter by letter. It is a common misunderstanding.

"As Matthew Carter puts it, type designers 'are really word-shape designers', but it took me several years to understand it."

Lithium

Lithium

1. Lithium typeface family, 2001
 Promotional material
 referencing the periodic table.

Ab C De Fg

Lm N Op Q Rs Tu

Y Za B Cd Ef Gh Ij Kl

Pq R St U Vw X Yz @

abcdefghijklmnopqrstuvwxyz
ABCDEFGHIJKLMNOPQRSTVWXYZ
0123456789
!"$%&'()*+,-./:;<=>?@~-""""

2. Lithium typeface family, 2001

Lithium, published by the TypeBox foundry, is Kobayashi's attempt at designing a 'trendy' design. It creates a modern, technological, electronic style, while retaining a humane sensibility.

The typeface was a progression from an earlier typeface, Calcite, previously published by Adobe.

abcdefghijklmnopqrstuvwxyz
ABCDEFGHIJKLMNOPQRSTVWXYZ
0123456789
!"$%&'()*+,-./:;<=>?@~-""""

abcdefghijklmnopqrstuvwxyz
ABCDEFGHIJKLMNOPQRSTVWXYZ
0123456789
!"$%&'()+,-./:;<=>?@~-""""*

abcdefghijklmnopqrstuvwxyz
ABCDEFGHIJKLMNOPQRSTVWXYZ
0123456789
!"$%&'()*+,-./:;<=>?@~-""""

abcdefghijklmnopqrstuvwxyz
ABCDEFGHIJKLMNOPQRSTVWXYZ
0123456789
!"$%&'()+,-./:;<=>?@~-""""*

abcdefghijklmnopqrstuvwxyz
ABCDEFGHIJKLMNOPQRSTVWXYZ
0123456789
!"$%&'()*+,-./:;<=>?@~-""""

abcdefghijklmnopqrstuvwxyz
ABCDEFGHIJKLMNOPQRSTVWXYZ
0123456789
!"$%&'()*+,-./:;<=>?@~-""""

abcdefghijklmnopqrstuvwxyz
ABCDEFGHIJKLMNOPQRSTVWXYZ
0123456789
!"$%&'()+,-./:;<=>?@~-""""*

abcdefghijklmnopqrstuvwxyz
ABCDEFGHIJKLMNOPQRSTVWXYZ
0123456789
!"$%&'()+,-./:;<=>?@~-""""*

41

3. The FF Clifford typeface
 family, 1994–1999

 This work won first prize
 in the text font category, as
 well as Best of Show at the
 First U&lc Type Design
 Competition in 1998.

EIGHTEEN CAPS, ROMAN & ITALIC.

GRAY'S INN RD WC1
Bibliographical Society
Austin's Imperial Letter Foundry
Punchcutter to the Fry firm of Bristol
Furniture, Quoins, Shooting-Stick, Chase, &c.

NINE CAPS, ROMAN & ITALIC.

NEVILL COURT EC4
Wilson's Long Primer
Thorne's Fann Street Foundry
Transferred from Glasgow in 1834
London office of Stephenson Blake & Co.

SIX CAPS, ROMAN & ITALIC.

CHISWELL ST EC1
Justifying the head
10-11 Little Queen Street
Letter-cutting is a Handy-Work
Caxton Type & Stereotype Foundry

BORDERS.

0123456789

abcdefghijklmnopqrstuvwxyz

abcdefghijklmnopqrstuvwxyz

!"$%&'()+,-./:;<=>?@~–""""*

ABCDEFGHIJKLMNOPQRSTUVWXYZ

abcdefghijk

"$%&'()+,-./:;<=>?@~–""""*

abcdefghijklmnopqrstuvwxyz

ABCDEFGHIJKLMNOPQRSTUVWXYZ

0123456789

4. The FF Clifford typeface family, 1994–1999

This extensive family started life in 1994 with Kobayashi creating drawings inspired by Alexander Wilson's Long Primer Roman type, combined with inspiration drawn from Joseph Fry & Sons' Pica Italic No. 3.

5. Linotype Conrad, 1999

The design of this family is based on the fifteenth-century type by the German printers Conrad Sweynheym and Arnold Pannartz. Although it is a revival of their work, as recognised in its name, it is an informal one, with the resulting type being significantly different from the original.

The design won first prize for text font in the Third International Typeface Design Contest (1999) and the Certificate of Excellence in Type Design from the Type Directors' Club (2001).

Extrabold

HUMANIST
Constantinople
Speculum Humanæ
Transitional Roman-Gothic
German scribes and Illuminators

Bold

CLASSICAL
Printing Offices
Frankfurt am Main
Workshop of Nicolas Jenson
Monastery at Subiaco, near Rome

Regular

WOODCUTS
Imperial Roman
German Goldsmiths
In the palace of De' Massimi
Tusculanæ Quæstiones by Cicero

Light

GUTENBERG
Arnold Pannartz
Nuremberg Chronicle
Vigorous gotico-antiqua type
The second type of Sweynheym &

CONRAD™

ITC
WOODLAND™

6. ITC Woodland typeface family, 1997

The Woodland family is based on Akira Kobayashi's own hand-lettering, using a flat brush and a square-edged pen.

ITC WOODLAND LIGHT

HABITAT
Wilderness
ECOLOGICAL
Natural History
QUESTION OF BALANCE
Brunchberry changes to red
FRESHWATER ENVIRONMENT
Winter wraps the forest in a shroud of ice

KNEADING CLAY
MAKES
A POT;
IN EMPTINESS
LIES
THE POT'S
UTILITY.

CUTTING DOORS
AND WINDOWS
MAKES
A ROOM.
IN EMPTINESS
LIES
THE ROOM'S
UTILITY.

LAO-TSU

ITC WOODLAND HEAVY

NATURE
Resources
MUSHROOM
Ancient forest
ENRICHING THE SOIL
The legacy of a fallen log
KEEPING THE EARTH FERTILE
In every ecosystem, energy is trapped

ITC WOODLAND DEMI

OXYGEN
Butterflies
LANDSCAPES
Mother Nature
OLD-GROWTH FOREST
Animals depend on plants
SUBTLE AUTUMN COLOURS OF
On the forest floor, mosses grow on the

ITC WOODLAND MEDIUM

RECYCLE
Meltwater
RURAL SCENE
Environmental
MOSS-COVERED LIMBS
Ecological history written
GOLDEN HUES OF VINE MAPLE
Subtleties of form and function require

7. ITC Silvermoon typeface family, 1998

The Silvermoon family was inspired by 1930s fashion magazine headlines, combined with influences from the Art Deco illustration and architectural styles commonplace during that period.

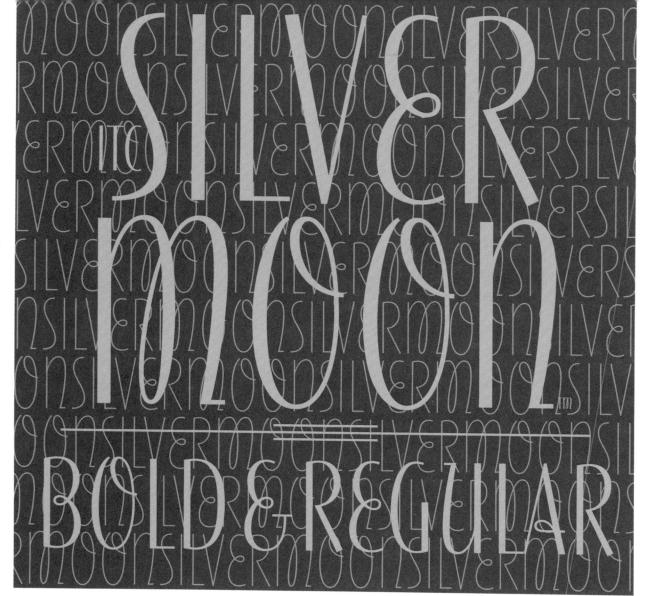

ITC SILVERMOON BOLD

EMPIRE
Ornaments
TWENTIETH CENTURY
Leave no space undecorated

ITC SILVERMOON REGULAR

ADELPHI
Modernism
ARCHITECTS IN THE 30S
Le Corbusier's L'Esprit Nouveau

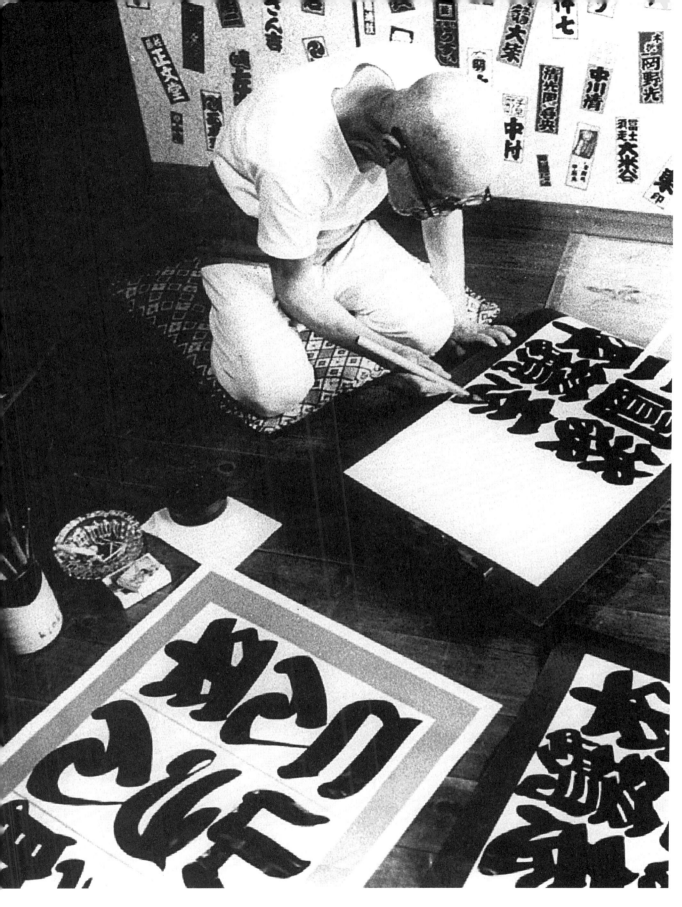

8. Ukon Tachibana (1903–1995)

Ukon Tachibana, master
of 'yose-moji', the Japanese
calligraphy used for comedy
playhouse billboards that has
greatly inspired Akira
Kobayashi's work.

Zuzana Licko

Much of the growth of typographic design in the last decade or so can be attributed directly to the development of the affordable personal computer and type design software. As the technology has developed to the point of near ubiquity, so new designers who have only ever worked with computers in their design work have come to the forefront of the field. It is true to say that their work is as much a product of their ability to understand and use computing technology as of their aesthetic and graphic skills.

One such designer is Zuzana Licko of Emigre. This is the independent type foundry established by Rudy VanderLans, Licko's husband, which publishes a magazine of the same name. Based in California, USA, *Emigre* was founded in 1984 – the same year that the Apple Macintosh was released. Originally set up as a magazine showcasing artists, architects, poets and photographers, the magazine's low print run (the first issue had a print run of just 500) meant there was no money available to pay for professional typesetting – the first issue being typeset with the unusual combination of a photocopier and a typewriter.

For Issue 2, Licko, freshly graduated from a graphic communication degree at the University of California at Berkeley, designed a set of three bitmap typefaces, Oakland, Emigre and Emperor (now incorporated into the Lo-Res typeface family), using the newly-released Macintosh. In the initial days of the Mac, before high-resolution output devices such as laser printers appeared, only low, coarse resolution devices such as dot matrix printers were an option. These early bitmap designs were born from those limitations, designed to get the maximum possible readability and quality from the new technology.

The appearance of these typefaces as part of *Emigre*'s second issue sparked interest from its readership, prompting Licko to release them for licensing with Issue 3. Over the following years, *Emigre* developed into a graphic design journal, while Licko continued her typeface designs in parallel, releasing the typefaces Citizen, Matrix and Modula.

These early high-resolution fonts were initially developments from her earlier bitmap work. Matrix, for example, borrowed the proportions

found in Emigre 14, while Modula, the first high-resolution outline font Licko designed, was based on Emperor 15. I asked Licko about her relationships with computers and typeface design, to find out how the two impacted on each other:

"I'd say it was mostly historical accident. I've never designed type any other way, so my style of type design developed out of using the digital medium. But I suspect that if it wasn't for the digital medium, I might not be designing typefaces for a living. Without the computer, I wouldn't have been able to produce my own fonts and build an independent type foundry.

"If I'd lived in the pre-digital type era, I may still have come to design typefaces by hand, but I doubt that many of them would have been licensed by the existing font manufacturers. It's hard to imagine, but true, that before personal computer technology, fonts required proprietary equipment and the economies of producing and promoting fonts had to work on a larger scale."

Licko elaborated further on her digital working methods:

"As it is, I do virtually all of my design and production directly in the computer. Usually, the only hand-drawing I do is on laser printouts, to mark areas that need adjustment, or to sketch alternate forms. Then I eyeball the corrections on screen. As a result, my typefaces do not contain traces of calligraphy or other media. Instead, all of the forms come from how I construct the letterforms in the digital drawing plane."

By 1989, *Emigre* had found success both as a magazine and as a type foundry. This enabled Licko and her husband to give up their freelance work in order to concentrate purely on the company. As a result of this renewed focus, Licko was free to expand the type foundry part of Emigre, both with her own creations (such as Base, the Tarzana families, and the revivalist families of Mrs Eaves and Filosofia) and with those of contributors.

Her own work progressed, creating what one might call more conventionally sophisticated typefaces, but still very much wedded to her methods of production in the digital realm. For example,

her Mrs Eaves typeface, a revival based on the typefaces of Baskerville (named after Sarah Eaves, John Baskerville's housekeeper and later wife), attempted to capture the natural feel and organic character of letterpress in a digital typeface. Whereas some designers have felt constrained by the clinical, precise nature of the computer as a typographic tool, Licko has embraced it and she and the technology have grown together:

"To a great extent, the gradual sophistication of my type design abilities have been matched by advances in the Mac's capabilities, so it has continued to be the ideal tool for me. Some 16 years ago, the Macintosh was unveiled at the same time as I graduated from college. It was a relatively crude tool back then, so established graphic designers looked upon it as a cute novelty. But to me it seemed as wondrously uncharted as my fledgeling design career. It was a fortunate coincidence; I'm sure that being free of preconceived notions regarding typeface design helped me in exploring this new medium more to the fullest."

Emigre now has over 300 typefaces by over 20 designers from around the world under its wing, along with a string of design awards. During its history, the foundry's typeface releases have often sparked controversy – I asked Licko how she judged the artistic and experimental worth of typeface contributions to Emigre:

"It is very subjective. For one thing, it depends on the intended usage. It also depends on what criteria you define as being important in your definition of worth; longevity of usage, intensity of usage, influence on other designers' work, etc. It takes the perspective of time to determine which typefaces remain classics, which become icons, and which fade away. It is the continual changing of these perceptions that drive our desire for new type design solutions. Over time, different solutions may be required to address the same design problem because context changes and results in shifting of meaning. Thus, the 'same old solution' tends to become boring and leads the audience to lose interest.

"In addition, new technologies and environments arise to present new problems for the designer to address. The most successful experimental typeface designs are often those that address the new needs of a new, yet uncharted technology.

"But if you're asking how we decide on which typefaces we release, it's as simple as: 'We know it when we see it.' We don't have a preconceived idea about what constitutes a good typeface design. For sure, it has to contain some originality, but originality in itself is not enough."

It is this experimental nature of Zuzana Licko's work at Emigre that makes, ultimately, for its success. It dared to embrace new technology, and often faced criticism from many in the design industry. Yet, nearly two decades on from those first bitmap typefaces, display technology has not significantly improved in terms of resolution. We have access to more colours, larger screens and apparently infinitely faster graphics-rendering technologies compared with the miniscule nine-inch, one-bit screen of the original Macintosh released in 1984; but actual screen definition resolutions still hover around the 85dpi mark. What was born out of necessity back in 1984 still has a place in these early years of the twenty-first century – a situation few in the industry expected.

Low-resolution devices look set to become increasingly common-place. The recent rise of the mobile phone and the PDA (Personal Digital Assistant) has brought about a resurgence in the need for small, readable bitmap fonts. European interactive digital television systems are already providing interactive information services (via 'walled garden' and internet services) down optical fibres or bounced off satellite. Typeface designers wishing to provide solutions for the typographic challenge provided by NTSC or PAL resolution television, or tiny mobile-phone screens, have a whole world of experimentation and problem-solving that simply didn't exist twenty years ago.

Perhaps it is unsurprising that Licko was such an early adopter of new technology, and has been so eager to contribute to the problem-solving of this new medium. Licko's father was a professional mathematician, and, to finish, I asked her if this had influenced her work: "Definitely. I enjoy solving puzzles whether they be math, logic or visual. Having a maths professor in the family probably fostered this to a great degree, which in turn made me receptive to using the computer as a creative and problem-solving tool."

1. *Emigre* magazine cover:
 Issue 33, 1995

 Cover design by
 Rudy VanderLans.
 The typeface is Dogma
 Extra Outline by Licko.

1.

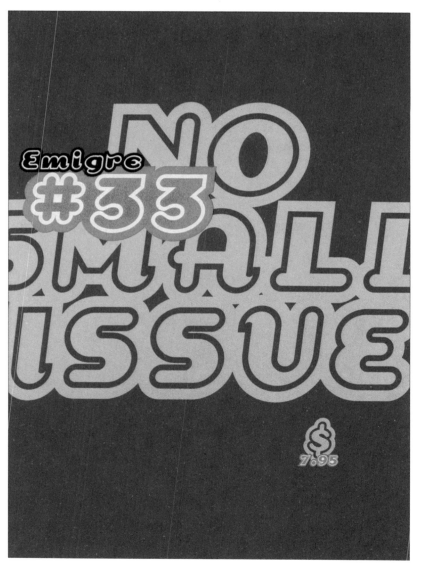

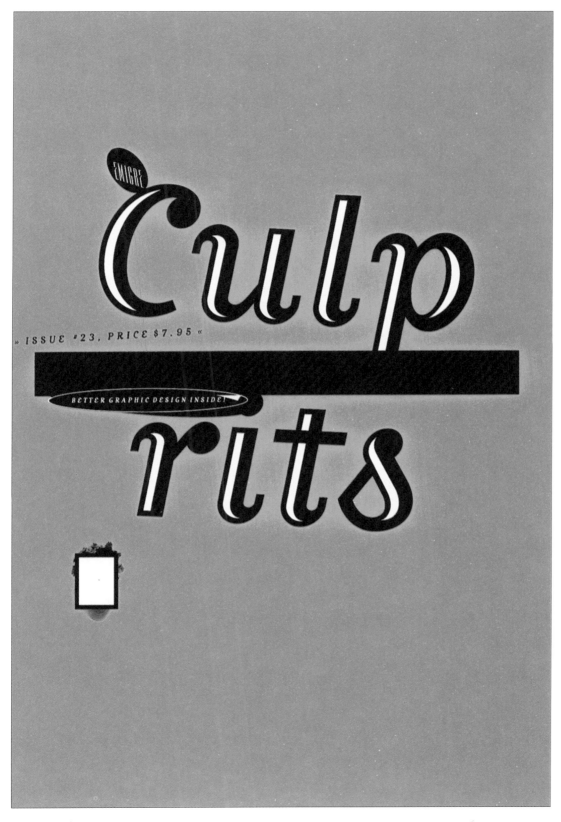

2. *Emigre* magazine cover: Issue 23, 1992

 Cover design by Rudy VanderLans. The typefaces are Matrix Script Inline and Matrix Script Bold by Licko.

3.

3. *Emigre* music poster:
 Basehead, 1991

 Poster design by Rudy
 VanderLans. Modula Bold
 and Modula Serif Bold
 typefaces by Licko.

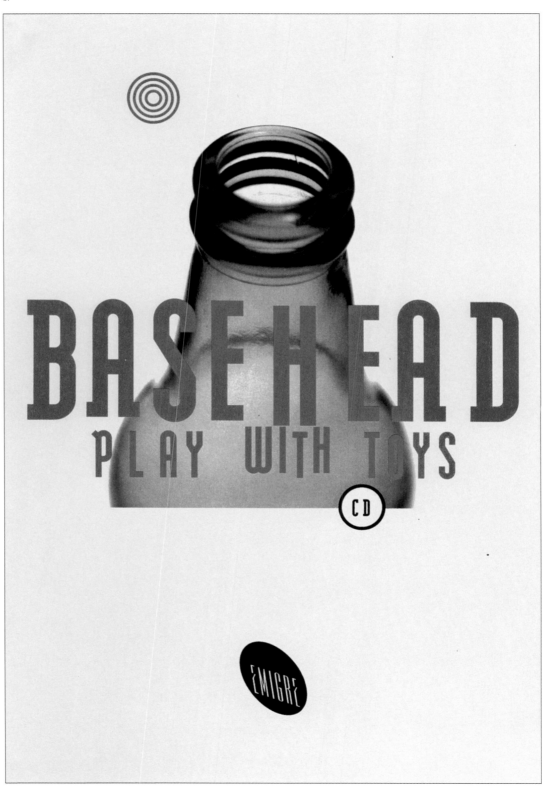

5. Coarse-resolution fonts, 1984–85

The Emperor, Universal, Oakland, and Emigre faces were originally designed as bitmap fonts for use on the 72dpi computer screen and dot-matrix printer, before high-resolution outline fonts were available. Since the coarse resolution does not allow for a faithful representation of the same design for a variety of sizes, these faces relate by a system of whole pixel increments rather than points.

6. Scaling Emperor 8 and Emperor 19 to the same capital-height measure illustrates why a higher resolution is required to render Emperor 19.

The numbers in the names of Emperor 8, 10, 15 and 19 refer to the number of pixels that compose the capital height.

7. Development of Matrix from Emigre 14, 1985

The design of Matrix is based upon the proportions of the Emigre 14 bitmap design. When Matrix was designed, the personal computer was very crude and memory space was very expensive. The character proportions are based on a few simple ratios and the points required to define the letterforms are limited to the essentials. For example, serifs with curved elements require more memory than do straight lines. Therefore, Matrix serifs are reduced to diagonal lines, requiring fewer points than even square serifs. The 45-degree diagonal, used in Matrix, is the smoothest diagonal that digital printers can generate.

OAKLAND SIX
Emperor Eight
Emigre Fifteen
Universal Nineteen

5.

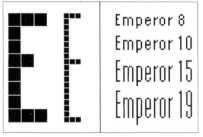

Emperor 8
Emperor 10
Emperor 15
Emperor 19

6.

Emi

Mat

7.

AGMS

8.

MATRIX

FGHIJKLMN
OPQRSTUVWXYZ

arics

MODULA SERIF BOLD

MODULA RIBBED

bcdefghijklmn

avson wxyz
abcdefghijklmn
opqrstuvwxyz

avson
abcdefghijklmn
opqrstuvwxyz

wcdfilmoAAADEF
KLMNOPXXVVUUW
CDEFGHIJKLMNOP
UVWWWZ rr

Dogma

8. Matrix Regular and Extra
 Bold, 1985–86

9. Matrix Inline, 1992

10. Modula, 1985

11. Modula Ribbed, 1995

12. Development of Base-9 and its
 corresponding bitmap, 1995.

 The Base families offer
 compatible screen and printer
 fonts to address the dual
 needs of low-resolution
 screen display and high-
 resolution printing. Base-9 is
 derived from the proportions
 of a 9-point screen font; for
 example, the proportions
 of the screen font determined
 the exact character widths
 within which the outline
 characters were adjusted to
 fit. With more traditional
 type designs, this process is
 usually reversed; character
 widths are normally adjusted
 to fit around the outline
 characters.

13. Development of Base
 Monospace, 1997

14. Whirligig, 1994

15. Dogma, 1994

abcdek
ABCDEGJKMNORSUVWXY
ABCDEGJKMNORSUVWXY
apcqey

17.

18.

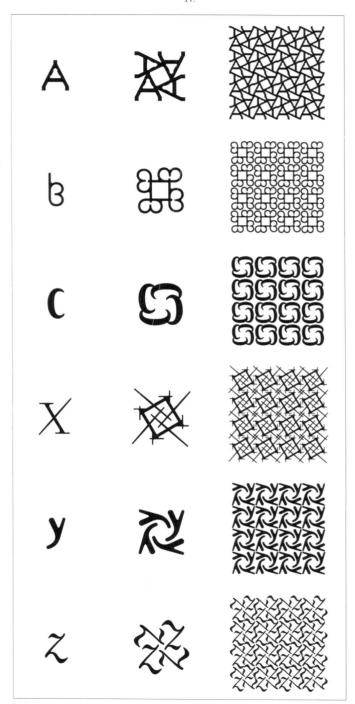

16.

16. Hypnopaedia, 1997

Each Hypnopaedia
illustration was created by
concentric rotation of a single
letterform. When repeated,
each illustration creates
a unique pattern of
interlocking letter shapes.

17. Tarzana Wide and
Wide Bold, 1998

18. Development of Tarzana, 1998

19. Mrs Eaves Roman, Italic
and Bold, 1996

This interpretation of the
Baskerville classic focuses
on capturing the warmth
and softness of letterpress
printing that often occurs
as a result of the 'gain' of
impression and ink spread.

20. Mrs Eaves Ligatures Roman
and Italic, 1996

21. Filosofia Regular, Italic, Bold
and Ornaments, 1996

Filosofia is an historical
revival based on Bodoni.

22. Hypnopaedia Pyjamas, 1997

23. Lo-Res 20s, Teens and 9s,
2001 (opposite page)

The Lo-Res family of fonts
is a synthesis of pixelated
designs, including the
earlier coarse resolution
fonts, as well as bitmap
representations of Base-9.

Ace
abcdefghijklmn
stuvwxyz01928
race

19.

HERO GOGGLES
We be freeky and flippy
SUPER SCHOOL
If you find energy sticky

20.

moce
{ abcdefghijklmn
opqrstuvwxyz }
nocev

21.

abcdefghijk
lmnopqrstuvwxyz
noce
abcdefghijklm
opqrstuvwxyz

21.

22.

Jean-François Porchez

Typographic design is unusual in all the graphic disciplines for being a product of its own past. The very nature of alphabets dictates this – the further away a typeface removes itself from the basic shapes that constitute the alphabet, the less readable (and thus less usable) your typeface becomes.

It is up to the typeface designer to find a means of creativity and expression of ideas through the alphabet's predefined set of elements, developed over thousands of years of history and human language. Understanding and working with this history is key in creating a typeface that will stand the test of time and serve its primary purpose – to act as a vehicle for communicating an author's ideas to the reader efficiently, and ideally, beautifully.

The city of Malakoff in France is home to the Porchez Typofonderie, the type design studio of Jean-François Porchez. Nestled in a suburb of Paris, it is perhaps unsurprising that Porchez's approach to typography is one rich in history and firmly based on cultural beliefs. He explained his philosophy to me:

"Each new typeface cannot live without its predecessors – all of them form one large family and are connected and influenced by each other. If Claude Garamond cut splendid type, then it is because he studied Italian typefaces and tried his best to improve upon them, imparting them with his own French view and culture. The reason Dutch typefaces are so powerful is just because the Dutch typographers took the best of French elegance to create efficient fonts 'with problem-solving qualities' by increasing x-height, quantity of space used, etc."

Born in 1964, Porchez initially left school to work in a music and book store for three years before returning to education in 1986. He studied graphic design, and during his studies developed an interest in calligraphy, and later, type design itself. Out of school hours, he started developing his own typefaces, and his first, Angie (designed in 1989), was entered for the Morisawa International Typeface Design Awards; it won the Judge's Prize. From this encouraging start, he went on to study at the *Atelier national de création typographique* for a year, before joining the French design agency Dragon Rouge as Type Director.

"You cannot understand typography and typefaces without knowledge and you can't keep that knowledge for only yourself."

However, like so many of his contemporaries, Porchez eventually decided that his type design work would be better served with the creative control and freedom afforded by running his own foundry. His chance came when, in July 1994, he proposed a new typeface design to *Le Monde* newspaper:

"To my real surprise, they accepted, so I left Dragon Rouge that September in order to focus on the future Le Monde family. It was at this moment that I decided that I would become an independent free-lance type designer, working on lettering, logotypes for design agencies and a few minor typeface projects.

"I launched my own foundry during the summer of 1996 with a couple of fonts, followed the year after by the huge Le Monde family and the creation of the website under the name porcheztypo.com. I just followed the example set by some American friends such as Summner Stone and others such as Matthew Carter and Jonathan Hoefler. In the early '90s, there was a move from big foundries to more human-scale companies started by these designers, probably due to the new, pre-web computer era."

While new, affordable computing technologies have made the option of independent foundries a reality for many designers, Porchez remains pragmatic on their role within the production process. He uses a wide variety of software packages, from Fontographer and FontLab to RoboFog, but throughout the process of designing his typefaces, he remains committed to producing a work of intellectual vigour, divorced from the technology he uses:

"The tools do not directly influence my designs. I don't want to be the slave to any of my computer tools – if a tool does not work in a way that I want, I will move on to another until I find one that works in my direction."

When Porchez sits down to start work on a typeface, the tools are merely there to facilitate his work, rather than to impart their own aesthetic on the design. His typeface design is always created with a specific goal in mind and I asked him to elaborate on his working approach:

"I have great difficulties designing fonts without a function or a brief. I cannot create new form just for the pleasure of it, it's more the reverse; the functions make me want to search for new forms. There are always exceptions, of course, but this is probably why I don't produce many roughs for future typefaces. I find that generally the concepts come after a long period of mental reflection, rather than a couple of fast drawings on paper.

"An example of this reflective approach is my design of Anisette, a couple of weeks after the initial *Le Monde* project. I wanted to experiment with a new way of designing typefaces; I started from a main inline to make condensed and extended versions in both thin and black versions in Illustrator, only creating outlines of the forms afterwards.

"I had always imagined that one day I would add some lowercase characters to the original double caps-width version of Anisette [designed in 1995]. Then, the morning after the completion of Ambroise in the late Spring of 2001, I started designing some forms directly on screen. Less than a month later, the entire Anisette family appeared ready for sale on the website. It takes a long time to think about and intellectually develop an idea, the design process is only a small part of the end result. Type design is an intellectual rather than a manual job, the tools don't directly influence the forms, it's more to do with what your brain, your own culture and influences, your reading, brings to the work that make the difference."

Jean-François Porchez's involvement in the type design community follows this same belief in practice; exchanging ideas with other designers and taking an active involvement in the education of a wider audience in the value of typography. He is the French delegate for ATypI (*Association Typographie Internationale*), and teaches type design at *École Nationale Supérieure des Arts Décoratifs* (ENSAD) in Paris. Combined with this work, he also publishes extensive articles on the Porchez Typofonderie website. I asked him about this educational role, and how it fits with the work of a type designer:

"From the early days, I have enjoyed sharing and exchanging knowledge and different opinions on type and other subjects!

I understood this very clearly when I went to my first *Rencontres Internationales de Lure*, in August 1989, held in a small village in the south of France. The aim of this association (created in the '50s by Maximilien Vox and others) is to help people to meet each other and discuss important typographical subjects. At the same time every year, they meet each other during one week of conferences and lectures. In my first year, I met the key people of French typography such as Ladislas Mandel, Gérard Blanchard, François Richaudeau, René Ponot and others. They were all very open-minded and accepting of young people like me, and were willing to freely discuss everything, from eight in the morning to very late at night! We can't live without learning, it's an important aspect of our lives.

"In fact, I started to teach only three months after finishing my time as a student. Teaching is a key part of me, so the idea of putting some articles on type on my website seemed very natural from the early days. You cannot understand typography and typefaces without knowledge and you can't keep that knowledge for only yourself.

"On the more pragmatic side, I don't see how to sell fonts without an explanation behind them. It's completely part of type foundries' history to publish views on typography – just take Monotype; typefaces are just an element of a wider world created by people such as Morison and Warde. Monotype fonts are nothing without their literature, whether published inside or outside the company. Type design is a cultural act, not just a few lines of data in the corner of a hard disk."

1. Various logotype and
 lettering designs

 Jean-François Porchez's
 typographic skills have been
 called upon in the creation
 of original logotypes, and the
 redrawing of current ones.

2. France Telecom development,
 1999–2000

 Porchez was commissioned
 in conjunction with Landor
 Associates to create a logotype
 and corporate typeface as part
 of a rebranding exercise for
 the telecom and internet
 company France Telecom.
 From top to bottom, we can
 see the development of the
 typeface from September
 1999 to February 2000.

3. The final solution resulted in
 a general-use typeface (top)
 and logotype (bottom).

2.

france telecom
france telecom
france telecom
france telecom

3.

france telecom
france telecom

france telecom LA POSTE

LES PÊCHERIES DE·NOSSI·BÈ naturelle

Truffon Le Monde AIR FRANCE Plancoët

Duetto TECNIFIBRE VALVERT CHRONOPOST

GL Guy Laroche Papèterie CREDIT LYONNAIS Info

MAROUSSIA BRUMMELL CLUB TOURTEL Libero

 MONT ST MICHEL PARFUMEUR DEPUIS 1920 air WICK William SAURIN BLEU D'AGATHE

Double douceur BANANIA SUEZ LYONNAISE DES EAUX Spanghero

PEAUDOUCE Rondelé AFTER'SCHOOL Uncle Ben's

Gervais la belle-iloise La Villageoise Royal cône

THALES Tonigencyl

64

Apolline romain & alternatives

Il faut conserver à la lettre

Apolline petites capitales & expert

l'aspect d'un dessin

Apolline italique & alternatives

au lieu de lui imposer

Apolline italique expert

une forme géométrique,

Apolline demi-gras & alternatives

en un mot la sauver

Apolline demi-gras italique & alternatives

de cette exécutable

Apolline gras & alternatives

perfection :

Apolline gras italique & alternatives

la sécheresse

Arabesques & ornements

George Auriol

65

5. Anisette typeface specimen sheet, 1995

6. Anisette typeface displayed as a specimen poster, 1995

6.

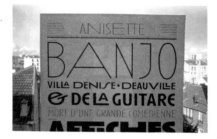

Jean-François Porchez présente

❧ AMBROISE ❧

7.

abcdefghijklmnopqrstuvwxyz
ABCDEFGHIJKLMNOPQRSTUVWXYZ
-<÷+|°%‰½¼¾€$¢ƒ£¥&0123456789¹²³ª°^×=~>¬
`´ˆ˜¯˘˙Åå Ææ Çç Ðð Éé Ê fifl Îî Łł Ññ Øø Œœ Þþ Pß Ùù Ÿÿ Šš ·°"˝ˇ
—«»,.:;•·¸¡¿#§¶@µ†‡*/()[/]{\}®©P™!?""'‚'…»–—
☞ ÆŒ NBæct ffffiffifl flffl gils st uy ☜
←❦№○123456789€£!?℗-.,:;×→

AMBROISE

8.

<small>AMBROISE LIGHT</small>

➺➺Ambroise (1790 ‡1876) est le plus célèbre des Didots. Cette renommée est dûe à la multiplicité de ses activités tout au long de sa vie qui a traversé la période essentielle du XIXᵉ siècle. Son père FIRMIN, LUI AVAIT DONNÉ UNE ÉDUCATION CLAS

<small>AMBROISE FRANÇOIS REGULAR</small>

➺➺Ambroise (1790 ‡1876) est le plus célèbre des Didots. Cette renommée est dûe à la multiplicité de ses activités tout au long de sa vie qui a traversé la période essentielle du XIXᵉ siècle. Son père Firmin, lui avait donné une éducation classique des plus distinguées, mais lui avait aussi enseigné à tailler des poinçons de caractères. SON ENFANCE A CONNU LES VIEILLES PRESSES EN BOIS MAIS À SA MORT, SA

<small>AMBROISE BLACK</small>

➺➺**Ambroise (1790 ‡1876) est le plus célébre des Didots. Cette renommée est dûe à la multiplicité de ses activi- tés tout au long de sa vie qui a traversé LA PÉRIODE ESSENTIELLE DU XIXᵉ**

<small>AMBROISE FIRMIN LIGHT</small>

➺➺Ambroise (1790 ‡1876) est le plus célèbre des Didots. Cette renommée est dûe à la multipli- cité de ses activités tout au long de sa vie qui a traversé la période essentielle du XIXᵉ siècle. Son père Firmin, lui avait donné une éducation classique des plus DISTINGUÉES, MAIS LUI AVAIT AUSSI ENSEIGNÉ A TAILLER

<small>AMBROISE VIGNETTES</small>

7. Ambroise typeface

Ambroise is a contemporary interpretation of various typefaces belonging to Didot's late style.

8. Example setting

9. Didot punch cuts, 2001

Porchez studied extensively the type samples and printed matter of the sixteenth-century period and style in researching Ambroise, including the Didot punch cuts shown here.

10. Ambroise typeface specimen on press

9.

10.

10

11. Parisine typeface family,
1999

As used for public
signage systems.

*typographie*typographietypographie*typographie*
typographietypographie**typographie***typographie*
TYPOGRAPHIETYPOGRAPHIE**TYPOGRAPHIE***TYPOGRAPHIE*
typographietypographietypographietypographie
TYPOGRAPHIETYPOGRAPHIE**TYPOGRAPHIE***TYPOGRAPHIE*
*TYPOGRAPHIETYPOGRAPHIE***TYPOGRAPHIE***TYPOGRAPHIE*
typographietypographietypographietypographie
*typographie*typographie**typographie***typographie*
*typographie*typographietypographie*typographie*

Parisine (5 premières lignes) L'ensemble des déclinaisons.
ParisinePlus Comparivement, les signes sont plus vivants et variés.

abcdefghijklmnopqrstuvwxyz
abcdefghijklmnopqrstuvwxyz
ABCDEFGHIJKLMNOPQRSTUVWXYZ
ABCDEFGHIJKLMNOPQRSTUVWXYZ
ffffififlfflaœctstsThEftHaleœ&0123456789
ffffififlfflaœctstsThEftHaleœ&0123456789

ParisinePlus abécédaire de base
incluant diverses ligatures

abcdefghijklmnopqrstuvwxyz
abcdefghijklmnopqrstuvwxyz
ABCDEFGHIJKLMNOPQRSTUVWXYZ
→fifl&0123456789←

Parisine abécédaire de base

Parisine Ouvertures différentes selon
les graisses pour un meilleur
équilibre visuel:
e extra light fermé
e black ouvert

Saffron
Gaston
QUENTIN
Thelma
Dagwood
GEE GEE
HERMAN
augustine
Justine
BERNARD

Parisine Plus
Utilisation des ligatures
dans différentes graisses

13. Le Monde typeface family, 1994–1999

The French newspaper *Le Monde* commissioned Porchez to create a family of typefaces for use in the newspaper.

14. *Le Monde* mastheads

Along with the extensive series of families created for the newspaper, Porchez also redesigned a series of mastheads for the paper's different sections.

15. Le Monde Livre Classic family

LE MONDE SANS

Hamburgefonstiv
HAMBURGEFONSTIV
Hamburgefonstiv
Hamburgefonstiv

LE MONDE LIVRE

Hamburgefonstiv
HAMBURGEFONSTIV
Hamburgefonstiv
Hamburgefonstiv

LE MONDE COURRIER

Hamburgefonstiv
HAMBURGEFONSTIV
Hamburgefonstiv
Hamburgefonstiv

LE MONDE LIVRE CLASSIC

Hamburgefonstiv
HAMBURGEFONSTIV
Hamburgefonstiv
Hamburgefonstiv

13.

Le Monde
Le Monde
La Lettre
Le Mondial
Le Siècle
L'Avenir
America

14.

Le Monde
ECONOMIE
Le Monde
INTERACTIF
Le Monde
TELEVISION
Le Monde
DES LIVRES
Le Monde
DES POCHES

Des livres
Some books on Type
finer French type cast by Mathis Porchez
& TES CARACTERES
LM Livre 012 AThMBctty Classic
LM LIVRE 0123456789 & CLASSIC
LM Livre 0123456789 & & Classic
LM Livre AThMBERſpctesty Classic
LM Livre 0126 AThcttyſ Classic

15.

Le Monde Journal

Il y a bien évidemment des rapp ORTS ENTRE LE MONDE & LE TIM es New Roman précédemment uti LISÉ PAR LE JOURNAL. LE TIMES ES

Il y a bien évidemment d ES RAPPORTS ENTRE Le M onde & le Times New Rom AN PRÉCÉDEMMENT UTILISÉ

abcdefghijklmnopqrstuvwxyz
abcdefghijklmnopqrstuvwxyz
ABCDEFGHIJKLMNOPQRSTUVWXYZ
ABCDEFGHIJKLMNOPQRSTUVWXYZ
ABCDEFGHIJKLMNOPQRSTUVWXYZ
0123456789 && 0123456789 ßfifl,.„-!?
0123456789 && 0123456789 ßfifl,.„-!?

RGabnofeg
RGabnofeg
RGabnofeg

RGabnofeg
RGabnofeg

Contexte historique

INITIALEMENT, les journaux n'utilisaient pas de caractères de texte spécifiques. Vers le début du XXe siècle, C. H. Griffith, de l'American Linotype Company, s'intéresse aux problèmes que posent les caractères de l'époque à la lecture & l'impression. Les caractères utilisés alors étaient majoritairement des caractères de type Didone caractérisés par un axe de construction vertical & la suppression totale de tout qui, jusque-là, tenait encore au tracé calligraphique. C. H. Griffith mit au point une série de caractères plus robustes, toujours construits sur un axe vertical, mais d'un aspect plus franc : le Ionic, l'Excelsior, le Corona. Ces derniers s'imposèrent facilement sur le marché des caractères destinés à la presse.

En 1931, Stanley Morison eut une approche complètement différente dans le développement de son caractère pour le Times. Il préféra les caractères plus livresques de la fin de la Renaissance française, comme le Garamond ou les caractères monumentaux tel que le Perpetua dessiné par Eric Gill. L'axe oblique est une des caractéristiques — des caractères de la Renaissance — avec un rapport pleins-déliés peu contrasté. Ces facteurs une fois additionnés & ajoutés à une chasse étroite firent du Times New Roman un classique des caractères de texte, de la presse quotidienne à l'édition.

L'invention de la photocomposition puis l'arrivée d'unités de productions de plus en plus petites & performantes permit de produire à moindres coûts des caractères adaptés à des situations particulières. Les créateurs de caractères maîtrisent à nouveau, comme au début de l'imprimerie, toute la chaîne de production. C'est dans cette continuité que le caractère Le Monde a ainsi put voir le jour.

HISTORICAL CONTEXT. Initially, newspapers did not use specific text typefaces. Towards the beginning of the twentieth century, C. H. Griffith, of the American Linotype Company, became interested with the reading & printing problems which were posed by the typefaces of the era. At the time, the majority of typefaces used were of the Didone genre, characterized by a vertical axis in their construction, & a complete suppression of everything which bore a calligraphic style. C. H. Griffith released, at this point, a series of more robust typefaces all constructed with a vertical axis but with a clearer appearance: Ionic, Excelsior, and Corona. These latest releases easily dominated the market for typefaces intended for newspapers.

In 1931, Stanley Morison took a completely different approach in the development of his typeface for The Times. He preferred the more bookish characters at the close of the French Renaissance, such as Garamond or Perpetua, designed by Eric Gill. The oblique axis is one of the characteristics of the typefaces of the Renaissance, along with a weak contrast in the relationship between stems and strokes. These factors, in addition to the narrow character set, made Times New Roman a classic text typeface for the daily production of newspapers.

With the advent of phototypesetting and the steady arrival of increasingly smaller and higher-performance equipment, typefaces could be adapted to particular situations at a low cost. Typeface creators could control, as at the beginning of printing, the entire production. It is in this continuity that the Le Monde typeface saw the light of day.

Axe droit–axe oblique

POURQUOI les caractères à axe droit paraissent-ils plus étroits que ceux à axe oblique ? Les formes des caractères à axe droit sont statiques & verticales, celles des caractères à axe oblique sont à l'inverse, dynamiques & horizontales. Comme on peut l'observer avec ces deux « e » : pour une surface utilisée identique, le caractère à axe oblique paraît plus large de l'intérieur. Il peut ainsi paraître plus ouvert lors du processus de lecture.

UPRIGHT AXIS, OBLIQUE faces with an upright axis appear more substantial than those with an oblique axis. The forms of the typefaces with an upright axis are static & vertical, with an oblique axis are, in inverse, dynamic and horizontal. This can be observed with these two « e » here : in identical face with an oblique axis seems to have a larger interior. It can, in this way, appear more open during the reading process.

Ouvertures

LORS DU PROCESSUS de lecture, la rétine se fixe sur le tiers supérieur de l'œil du bas-de-casse. C'est pourquoi les caractères ouverts sont plus faciles à lire. Leurs formes se différencient plus vite leurs rapport aux autres. Ci-dessous une comparaison entre l'Univers dessiné en 1957 par Adrian Frutiger & le Monde Sans.

OPENINGS. When the process of reading, the retina is fixed, on the top third of the lowercase letter. This is why open typefaces are easier to read. This forms designed at each letter more quickly. Below is a comparison between l'Univers, designed in 1957 by Adrian Frutiger & le Monde Sans.

La typographie est lisible
La typographie est lisible

Formes idéales

aes
aes

adgqo

Petites capitales

LES PETITES CAPITALES ont la particularité de s'aligner optiquement avec la hauteur d'œil du bas-de-casse. Certains logiciels proposent de fausses petites capitales.

PETITES CAPITALES (Fausses)
PETITES CAPITALES (Vraies)

une des raisons pour lesquelles des petites capitales existent dans toutes les graisses & italiques de base & cela pour l'ensemble de la famille Le Monde. Ci-dessous, un exemple de petites capitales (au fil) superposées & agrandies à la taille des grandes capitales.

SMALL CAPITALS. Small capitals are especially designed to optically align with the x-height. Certain programs have the option of false and aesthetically incorrect small capitals, which are produced mathematically. This is one of many reasons small capitals are offered in all basic weights & italics, on the whole, for the Le Monde family. Below, an example of small capitals (in outline) superimposed & enlarged to the height of large capitals.

Chiffres

0123456789$¢£¥f
9876543210€f¥£¢
0123456789

Rian Hughes

Typeface designer, cartoonist, illustrator, graphic designer; it's hard to categorise Rian Hughes. He works on a vast range of projects out of his studio in London, within earshot of Kensington Gardens, and his clients demonstrate the diversity of his talents. They provide a broad range of creative briefs from editorial illustration in magazine publishing and artistry for the cartoon industry, through to graphic design and branding for the music industry, national institutions and international companies.

His website (www.devicefonts.co.uk) doesn't help in pinpointing exactly what Hughes is either, with its portfolio covering the wide spectrum of work he handles. The reason is simple, he told me:

"I would hope that if you're creative then you can be creative in lots of different areas. They [the clients] are not employing you solely for your technical skills, they're employing you for your quality of thinking ... you don't want to be a stylist who people commission because they want a particular sheen laid across what they're doing. A lot of people fall into that trap. To keep it interesting, you've got to keep it fresh and new."

Hughes studied graphic design at the London College of Printing. He then spent his first two years out of college working in a range of jobs, including magazines such as *ID*, *Vogue*, *House & Garden*, *Tatler*, and others. He also spent time with John Waricker of Tomato. Aside from illustration and design, he has also been a prolific cartoon artist.

"I used to draw comics pretty much full-time. While I was working for all these different outfits doing design, advertising and record-sleeve work, my work in comics suddenly took off. I quit my previous jobs and became a comic-strip artist on *The Science Service*, *Dan Dare* and *Revolver* – and then on to *RoboHunter*, *Really & Truly* and *Tales from Beyond Science* in *2000AD*, working with writers like Grant Morrison and Mark Millar. I got to the point where I was doing all this other stuff too: advertising, illustration, type design, logo design. Then I was offered Adam Strange in [Washington] DC, which is a regular 28 pages a month, but I turned it down. You pretty much can't do anything else but that, and although it was something I really wanted to do, it meant that it was the only thing I could do. I kind of had to turn my back on the comic-book stuff, I might go back to it at some

"I would hope that if you're creative then you can be creative in lots of different areas. They [the clients] are not employing you solely for your technical skills, they're employing you for your quality of thinking..."

future date, but it's too constraining a thing to solely do and I wanted to work more broadly in graphic design."

His first fonts were released back in 1992 as a progression of his work. Initially he published his work through FontFont, but then decided to go it alone with his own foundry, Device Fonts.

"I had a whole backlog of fonts that I was using for my own work and had been using on magazines such as *Deadline*. They didn't exist as whole international character sets at that point; it was just what I needed for the work. I spent some time completing the full complement, then thought it best to launch them all under the Device foundry banner and so, in 1995, the first 100 came out together.

"I think it's essential, as someone who believes in honing things to perfection, to separate yourself and maintain your own commercial identity that people can rely on in terms of quality; knowing the fonts will be well crafted, kerned and tested."

Hughes finds a wide range of artistic influence from comic artist Hergé, type designer Roger Excoffon, Saul Bass and novelist Neal Stephenson, for example. He is also inspired by general ephemera:

"I've a subscription to *Scientific American* and I'm a huge fan of *Thunderbirds*. I've got an enormous collection of science-fiction books and magazines. From the ages of 12 to 16 that's pretty much all I read, so I'm really steeped in it.

"My dad was an architect and would bring home Letraset sheets with 20-odd letters left on them that I'd play with. He had a catalogue with all the different Letraset faces which I've still got somewhere, I know that thing off by heart. I'd sit there and examine it and try and draw my own typefaces. It was a childhood fascination with letterforms, what they conjure up and how they're constructed."

Hughes visited the Letraset company when he was 15, where he saw Rubylith being used for the first time to create type.

"What they used to do at Letraset and places like that is to cut each letter individually from Rubylith, which is a thin, red, transparent masking film on a tranparent base you cut with a weighted knife. You'd peel away the excess and get this letter which you would photograph

down and duplicate to make the Letraset master-sheet from. This guy at Letraset showed me how it was done and I was absolutely fascinated. The degree of control that you have to have over it, the technical facility you need to get smooth curves ... and these guys were experts at cutting intricate shapes out of this stuff!"

This is the technique he used in the early days of his career when producing custom type for his design work:

"In the early days , pre Mac, I used to cut letters out of Rubylith at a large size and PMT [photo-mechanical transfer] them down, cut them out and reassemble them into the headlines I needed by pasting them on the board. It was all a very long-winded and laborious and rather tedious prospect. My early fonts like Crash Bang Wallop were digitisations of fonts I had done in this old-fashioned method of Rubylith on board."

These days, most of his work is done on computer, drawn in Adobe Illustrator and assembled and output using Macromedia Fontographer.

"I find it much easier to refine things on the computer. If I have an idea I'll write it down in a notebook as a pencil doodle, but then I'll go straight onto the computer with that idea in my head.

"If you're doing a font that's cursive, then obviously the history underlying that is of the movement of the hand. Whereas if you are doing a font that derives its history from geometric construction, the Mac is a much better tool for that geometric construction than pen and paper. If you're extremely au fait with the Mac then it's not going to do anything other than enable you. I've done fonts such as Chascarillo using marker pen on toilet paper scanned in; you should use whatever is suitable for the font. In that specific case, that was the type of feel I wanted, the gestural quality of the hand's movement. Think about what you're doing and the way you're doing it. As long as that process is there you're not just making arbitrary aesthetic decisions as you go along.

"Something like Paralucent is entirely derived from the mechanics of the computer, and is not a font that you would sketch out first. But that's not to say it's been mechanically done. You're still adjusting things visually, constructing forms with mechanical means, but judging them visually, rather than on a mechanical basis. When something is

mechanically correct it's not always visually correct. The computer leaves its signature too heavily on some fonts."

Many of the fonts that Hughes has created over the years have been derived from his illustration or design work, where a particular need has arisen, and a font is born from that need's solution. A typical example is one of his most popular fonts to date, Blackcurrant:

"Blackcurrant came from a Yellow Boots poster. Blackcurrant Black is unicase. In other words, you've got upper- and lowercase mixed. I was quite pleased with it as a logo and decided to develop it into a font. I then produced a more condensed version called Blackcurrant Squash, because an extended font is quite hard to use in many cases and I thought the new version would be more usable. About two years later I came back to it and designed a lowercase to go with both the Black and Squash versions, and in the process designed a purely uppercase version. This has gone on to be one of the most popular fonts I've designed."

Rian will often return to a face at a later date and refine it, but he uses his experience to know when to stop:

"What I tend to do is apply what I've learned to the next font I design. I always dry-run fonts in my own work, improving them in the process – refinements like precise kerning of en-dashes under 'T's. It is a polishing that most people wouldn't notice and that I end up getting obsessed with. When you've done quite a few different fonts and different styles you know the type of tweaking you'll need to do as you go along. Once you've got the gist of it, lessons learned by trial and error are incorporated as you work on future fonts."

THE BATMAN

BATMAN

1. Gargoyle Black typeface and *Batman* logo, DC Comics, 1998

 Hughes was asked to create a logo for the *Batman* series. The font, Gargoyle Black, was inspired by that logotype design work.

abcdefghijklmnopqrstuvwxyz
ABCDEFGHIJKLMNOPQRSTUVWXYZ
0123456789
!"§%&'[]‡+,-./:;(=)?@~-"""

2. Citrus typeface, Body Shop, 1995

 Citrus was originally designed for an international Street Scents campaign for high-street store The Body Shop. Blank posters were printed full colour and distributed to various countries, who then silk-screen printed various languages in white over the top (right).

abcdefghijklmnopq
rstuvwxyz
ABCDEFGHIJKLMN
OPQRSTVWXYZ
0123456789
!"$%&'()*+,-./:;(=)?@~-"""

get
street
scents

THE BODY SHOP

3. Logo designs, various, 1989–1995

Hughes' work includes many extensive logotype designs for a wide range of companies.

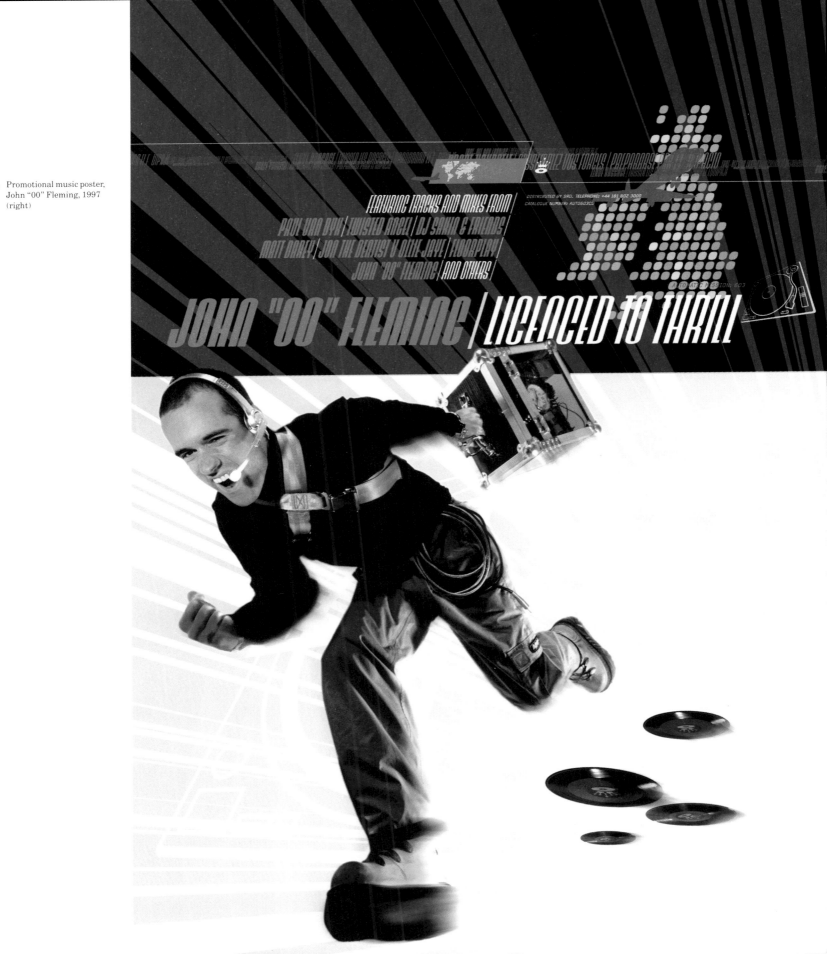

4. Promotional music poster,
 John "00" Fleming, 1997
 (right)

5. Doom Patrol logos,
 DC Comics and Doom
 Platoon typeface, 1996

 Many of Hughes' fonts
 originally started life as
 logotypes. For example, he
 designed a series of logos for a
 comic called *Doom Patrol*, one
 of which later provided the
 basis to the font Doom Platoon.

6.

6.

7.

8.

9.

10.

11.

6. Poster, Yellow Boots, 1997 and Blackcurrant typeface, 1998

Hughes' work for Yellow Boots, a Japanese fashion house, gave rise to his most popular font to date, Blackcurrant. Originally a unicase font (no upper- or lowercase to speak of), Hughes later went on to develop a whole family of faces.

7. Magazine cover, *MacUser UK*, 2000

MacUser has a long tradition of getting guest designers to illustrate its pages and cover in each issue.

8. Eurostar promotional posters, Eurostar, 2000

The Eurostar poster campaign ran across the UK in an attempt to appeal to travellers outside the business travel market.

9. Promotional poster for writer Kurt Vonnegut, 1998

10. Psybadek game poster, Psygnosis, 2001

11. Book jacket, *Visitors from Oz*, 2000

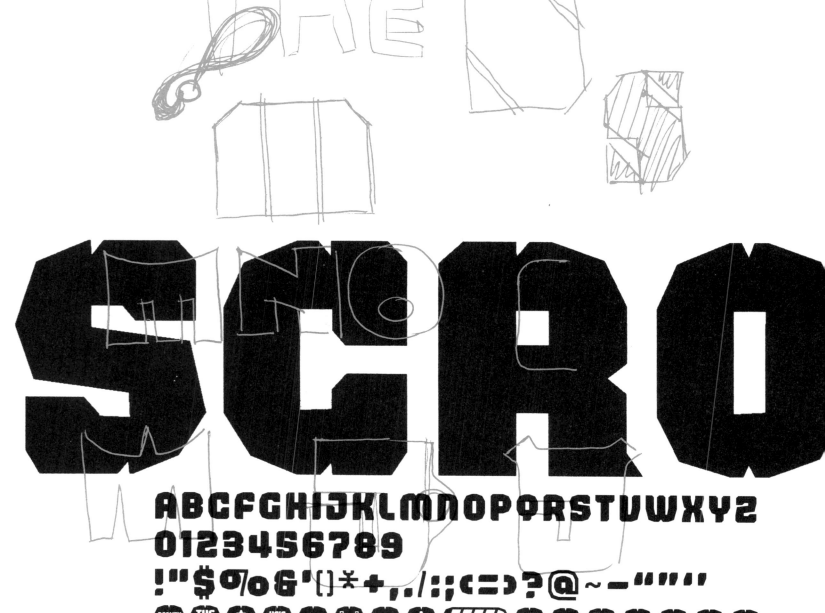

ABCFGHIJKLMNOPORSTUWXYZ

0123456789

!"$%&'()*+,./:;<=>?@~-""'''

12. Early developments of
 Judgement typeface, 1998

When experimenting and
refining the design of a
type-face using his Mac,
Hughes will continually print
out examples, checking and
re-checking his work as he goes.
In this example we can see
work on his font Judgement,
a font he created for the comic
2000AD. The final version's
character set and icons can be
seen bottom left.

Carlos Segura

Running one's own foundry can be a frustrating but rewarding experience. The realities of commercial life are such that many designers of all disciplines are faced at some point in their lives with the desire to strike out on their own. This need is often fuelled by a distaste for working in large type foundries, design houses and advertising agencies, where their work is often too heavily dictated by the politics of those in control or the stifling constraints imposed by corporate clients wanting 'safe' solutions. As designers ascend the corporate ladder, they often find themselves becoming more and more removed from their base activity – design – spending their time in endless meetings.

Yet, the cruel irony is that in many cases, going alone is a double-edged sword – yes, you have creative control at last, but you also have the mundane responsibilities of running a business and ensuring the bills are paid. Carlos Segura's foundry, called [T-26], is an example of how, by remaining small, tight, but talented, a creative business can achieve the ideal of being successful and innovative.

In 1965, aged just nine years old, Carlos left his home in Santiago, Cuba, with his family to start a new life in the USA. Raised in Miami, he became involved in the creative world from an early age as a drummer in a band, his role extending beyond percussion into designing the band's publicity materials. Having worked for a variety of advertising agencies in New Orleans, Pittsburg and Chicago he, like so many other designers before him, became disillusioned with their predicament, and left to start his own agency. Segura Inc, situated in Chicago, over 2000 kilometres from his Cuban birth place, was founded in 1991. From Segura Inc, Carlos went on to found a number of side companies, including ThickFace Records, 5inch and, of course, the [T-26] type foundry.

I asked Carlos about his reasons behind founding [T-26]:

"[T-26] started from a font that I did called Neo for a client in 1992. We got so many calls asking if it was available, that we decided to try to start something new.

"At the time, it was very difficult to find experimental type without going through an extensive search, or drawing it yourself, so we focused

on a plan to build a community of global designs from sources that were being ignored, such as new up-and-coming talent and students.

"We also wanted to start a foundry that was different in how it behaved and performed. We were (and still are to this day) the only foundry that offers discounts to full-time students. Our fonts come with a ten-printer licence – when we launched [T-26] in 1994, the standard was one. We also have a series of fonts specifically created to generate funds for non-profit organizations. All of the proceeds for these fonts are donated to efforts chosen by us."

Many foundries have started this way, focusing on innovation and experimentation, yet have lost their way as they become successful. It is all too easy for a company that receives critical and commercial success to lose focus on the reasons and goals that underlie it. I asked Carlos if the success of [T-26] has come with a threat to those original goals:

"Absolutely not, in fact it has made us more committed to the effort. I'd like to mention that while we have grown, it has been more in presence and standing within the community than in size. We are the same size we were when we started, with the obvious exception of the dedicated and growing group of global designers we are privileged to work with.

"One reason is that we feel we are part of a dwindling group of creatives who are simply trying to hang on in the face of a wider trend towards 'safe' alternatives. We try new things. When you do that, the risk of failure is greater, and most are unwilling to go down that road."

What he describes in modest terms as being a 'growing group' is, in reality, more of a swarm – [T-26] currently has over 200 designers around the world producing its range of 2000 typefaces! I asked Carlos how he assessed the designers (and their designs) for entry into this collective:

"We do not have a specific style we stay with. We are always looking for new stuff, and we get entries from all over the world each week. Our entries come in a variety of ways. Some fax it to us, or mail us a full promotional kit, others send us a JPG or a PDF via email, and

some create a Flash animation or even do a mini website to showcase their creation. The entire studio votes for their favourites once a week. Most of the time, we go with that. On occasion I overrule a choice or two citing an observation that I think the group might not have considered.

"I select fonts based on a variety of issues. How useful is it? How many members does a family contain? Does it have a full international character set? Which of our markets will embrace this effort? – this does vary. Can it be used for more than the 'delivery of words' (for decoration)? Can the font generate other renditions that might spark a separate exercise? What can the price be?

"Once we decide, it goes through an extensive process that sometimes takes months to complete, from testing to launch."

Carlos makes continual use of the word "we" in conversation, emphasising the community nature of [T-26]. But of course he himself is a type designer in his own right – his typeface portfolio includes Boxspring, Faxfont, Flaco, Neobold, Simple, Time in Hell and, in collaboration with the designer Tnop, Square 45. It is perhaps his understanding and personal experience of type design itself that makes him so adept at running a foundry that brings together so many designers from around the world. This motorcycling designer, whose company has its own Pet Department (currently staffed by Yuki the Labrador), is anything but a typical pinstripe-wearing businessman.

However, [T-26] is ultimately a business – and as such the creative side of running a foundry has to balance with being a growing company.

"One of the best things I like about [T-26] is the absence of 'clients' (I know this sounds odd). We control our destiny down to what level of intrusion we accept in our lives, and that includes meetings. There is no point in growing to a level that changes who you are. We are selective. I work very hard at making this place a good experience and I can't do that if we turn too corporate."

1. [T-26] font kits

 Segura's extensive advertising background and ownership of Segura Inc, his design agency, naturally lends itself to producing particularly polished promotional material, such as these Font Kits, containing specimen sheets and example works using [T-26] typefaces.

2. |T-26| promotional postcard
 (background image)

3. |T-26| promotional poster

 T26 produces a range of
 promotional posters that
 concentrate on promoting
 general creativity, rather
 than simply pushing a
 particular typeface.

3.

GAZZ

abcdefghijklmnopqrstuvwxyz
ABCDEFGHIJKLMNOPQRSTUVWXYZ
ABCDEFGHIJKLMNOPQRSTUVWXYZ
ABCDEFGHIJKLMNOPQRSTUVWXYZ
abcdefghijklmnopqrstu
ABCDEFGHIJKLMNOPQRSTUVWXYZ

GAZZ [SIX FONTS] $49

GAZZ IS DESIGNED BY MARIO FELICIANO • ITEM #T0300

888-T26FONT

[T-26] DIGITAL TYPE FOUNDRY supplement number 23

7.

PRINTED BY ROHNER LETTERPRESS 8040 RIDGEWAY SKOKIE ILLINOIS 60076 TELEPHONE 847-763-1301 FAX

8.

9.

9.

8. |T-26| font disk cases (top left)

9. |T-26| mailers (bottom left, right)

10. [T-26] promotional book (left)

 One of the more unusual and
 costly pieces – the book is
 bound into a powder-finish
 aluminium jacket.

11. [T-26] box sets (right)

Erik Spiekermann

Typefaces are quite remarkable things. Within the constraints of the glyphs of the alphabet, skilled typeface designers can convey emotional, social, tonal, geographical, even political information, before the first few words have even been read.

The personality imbued into a typeface by its creator directly influences how we react to the information the text itself carries. The evidence of this is all around us – newspapers the world over use rigid, stern, classical serif typefaces to convey an air of authority or 'truth' in their writing. Compare this with, say, the anarchic typography used during the early days of the punk movement (before the style became a parody of itself) and you get an instant feel for how a typeface's personality can influence the perception of a text.

Erik Spiekermann is no stranger to either. He began his career by setting metal type in the basement of his house in order to finance his study of art history at Berlin's Free University, before moving to London to spend seven years as a freelance graphic designer. Spiekermann is perhaps most famous for being one of the three partners who, in 1979, founded the branding and information-systems design specialists MetaDesign in Berlin, Germany. To complement this work, Erik founded FontShop International in 1989, publishers of the FontFont range of typefaces, including many of his own typefaces such as FF Meta and FF Info. Since leaving MetaDesign in the summer of 2000, Erik has returned to the freelance-design life, working as a consultant and spreading his time between Berlin, London and San Francisco.

With such a wealth of experience in brand identity and typeface design it is unsuprising that he has a strong belief in the power of typography to enhance a brand. Before I explored this with him, I asked him how he developed his passion for type:

"I fell in love with type when I first touched it, setting little bits and pieces and printing it on my little table-top platen (was that early desktop publishing?). I was 12 at the time.

"In later years, when phototypesetting had taken over, I wanted to have some of my favourite metal faces on film. In 1977, my typesetting and printing business burnt down, just after having moved it from

Berlin to London. I didn't have proofs for faces like LO-Schrift, Berliner Grotesk or Block, but found bits and pieces in old books. I persuaded Günter Gerhard Lange at Berthold that these faces needed reviving and they paid me for drawing up those families. I combined Berliner Grotesk Halbfett (Medium) and Block Light into the new Berliner Grotesk. LO-Schrift (after Louis Oppenheim) became LoType with a new regular weight designed from scratch and all the other weights redrawn as faithfully as I could, seeing that all the specimens came from different sizes and I had no complete alphabet showings anywhere. I made real pen-and-ink drawings and had them critiqued by Lange. Altogether a great training."

The technology of the day has moved on since those early pen-and-ink drawings. I asked him how he now approaches his designs:

"I sketch very quickly with a soft pencil, make photocopies of pasted-up letters and then digitise some – initially, just a test string such as 'Hamburgefonstiv'. As I am not very good at digitising, I only use the data for early presentations and then get other designers to complete the alphabets, correct my horrible outlines, extrapolate weights, etc.

"I am now getting back to learning the programs, but I still draw more quickly than I digitise and I prefer to work as an art director, creating the concept and then overlooking other people's work, very much as Lange did with me 24 years ago."

Spiekermann worked using this model on FF Info, a family he originally designed himself, but which has grown to include work from Ole Schäfer. The two work on a wide variety of typeface projects together at MetaDesign. I asked how they collaborated on such projects:

"Ole started doing new weights for Officina when he was at college which he showed to me. I critiqued it and he ended up making a range of weights which were later published. By that time, Ole had come to work with me at MetaDesign in Berlin. For a while, he was Lucas de Groot's assistant, but then Lucas left to set up on his own and Ole became our resident type designer, with him digitising my sketches. As he has his own style by now, I sometimes have to insist on him following my guidance, or my faces will start looking like his. A lot of the

concepts I hadn't had time for became Ole's own typefaces once he went freelance about three years ago. He still works with me, because he can read my shorthand and he is a very fast Fontographer operator.

"Info had started as a typeface for an Italian pharmaceutical company back in 1988, digitised with the first Ikarus M program available. I literally found a disk with the data in my appartment and gave it to Albert Pingerra, then Lucas' assistant at Meta (before Ole), who cleaned it up. When Düsseldorf airport came along, we realised that FF Info did not only fit the bill because it was designed for signage (rounded corners speed up plotting and avoid light shatter, and the closely related weights work for back-lit, front-lit signs in both positive and negative versions), but it also gave the airport an exclusive voice."

The idea of an "exclusive voice" is a concept that branding agencies all over the world now see as an increasingly integral part of a comprehensive brand identity. Modern corporate identity manuals are specifying typography, not just in the traditional type guidelines and usage arena, but they are also specifying custom typefaces that have been commissioned for their own use.

Typefaces have an extraordinary ability to communicate ideas beyond the basis of the individual glyphs, yes, but can a typeface ever truly give a meaningful expression to any company's brand values, given its inherent constraints?

"The 'brand value' is doubtful, as corporate typefaces can only look so different from other faces. If it looks too weird (for example, the National Westminster [NatWest Bank] face) it won't last very long, and it'll only be suitable for advertising. If you design a face which works on screen, on paper, on signs and in all sizes, you'll end up with another Arial or Frutiger. Just look at the new face for Siemens. Beautiful, but looks like Myriad, which is the Californian version of Frutiger. So you have to build in some quirks, or else nobody inside will recognise 'our' new typeface, but don't go overboard. When I just designed a family for Nokia (the digital work was done by Monotype), I started with the bitmaps from the phones (which I also redesigned) and drew over those. They have a lot of contrast (one row of horizontal pixels, two vertical) and are thus a little

more specific. But you end up with a large family – condensed for advertising, a display version, an office and on-screen version (wider, like Verdana), and a serif version for the more traditional stuff.

"The main advantage of a corporate typeface is its distribution. If you specify Futura or Univers or Helvetica, you'll get dozens of different versions around the world. If you rework Futura, as we did for Volkswagen, you can not only improve characters, adjust weights, include special or new glyphs (like the ¤ or the @), you can also rename the font. Volkswagen now have Volkswagen Headline aka Futura; Audi have AudiSans (Univers with a true italic) and AudiSerif (Times with stronger serifs). You pay a licence to the original foundry or designer, but then you can put the face onto a CD or onto the company's intranet for distribution, with a set of guidelines or templates. Even if you don't change a thing, you can just rename the face and make sure that all your suppliers use the right one. Lots of companies do that now, sometimes only for a campaign, where the agencies have to buy the package from a distributor like FontShop.

"I still think that every corporate design program needs an exclusive typography. That may just be a combination of a sans and a serif without any changes, an adaptation of an existing one (I did a News Gothic for Heidelberg, called Heidelberg Gothic, which is combined with Swift, called Heidelberg Antiqua) or something truly exclusive. I think some of the exclusive designs don't work too well because they simply haven't got enough character. British Airways, for example, is simply a boring typeface (designed by committee and Robin Nicholas) that has no reason to exist. And the one for Siemens is beautiful and totally bland. Maybe every company has the typeface it deserves, after all."

1. Letterpress printing, 1971

 Erik Spiekermann began by setting metal type in the basement of his house in order to finance his studies at Berlin's Free University. These small postcard-size announcement cards were set by hand and printed on a platen press. He says of these two examples, "The limited amount of illustration blocks at my disposal made me use the image of a pram both for a wedding (wir heiraten) and a birth announcement."

2. Berliner Grotesk / LoType typeface families, 1979

 Reproductions from hot-metal type specimens for Berliner Grotesk Light.

 Erik took 35mm negatives and printed them onto bromide. These bromides were then projected onto transparent paper where the outlines were traced by hand.

 The first proofs of LoType Light, complete with hand-written corrections by Berthold's Artistic Director, Günter Gerhard Lange.

3. Hand-set and hand-printed page for a sculptor's catalogue.

wir heiraten

am 1. Oktober 1971
Marlis Solveig Hecht
Dietrich Markgraf
1 Berlin 30 Mansteinstr. 16

jefirey * 31. 10. 1971
nanna bleck
roger garrett
1 berlin 12
bleibtreustraße 3

1.

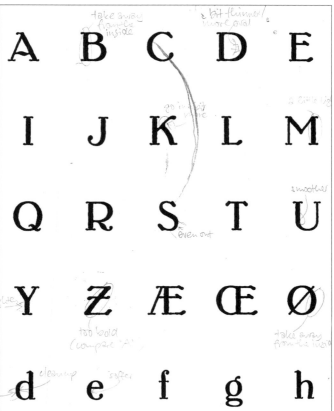

2.

SCHRIFTMUSTER

fiebig faltet. fiebig fummelt.
fiebig knickt. fiebig hat einen schwarzen anzug.
**fiebiG ist
Konstruk
tivist.**
fiebig ist scheißautoritär.
(manchmal kann er einem ja
ganz schön auf den Wecker fallen!)

3.

4. The Economist magazine redesign, 2001

The redesigned headline weight has been straightened up and is lighter: partly through taking out some of the noisy details; partly through wider tracking.

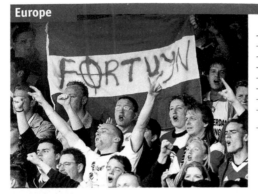
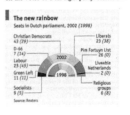

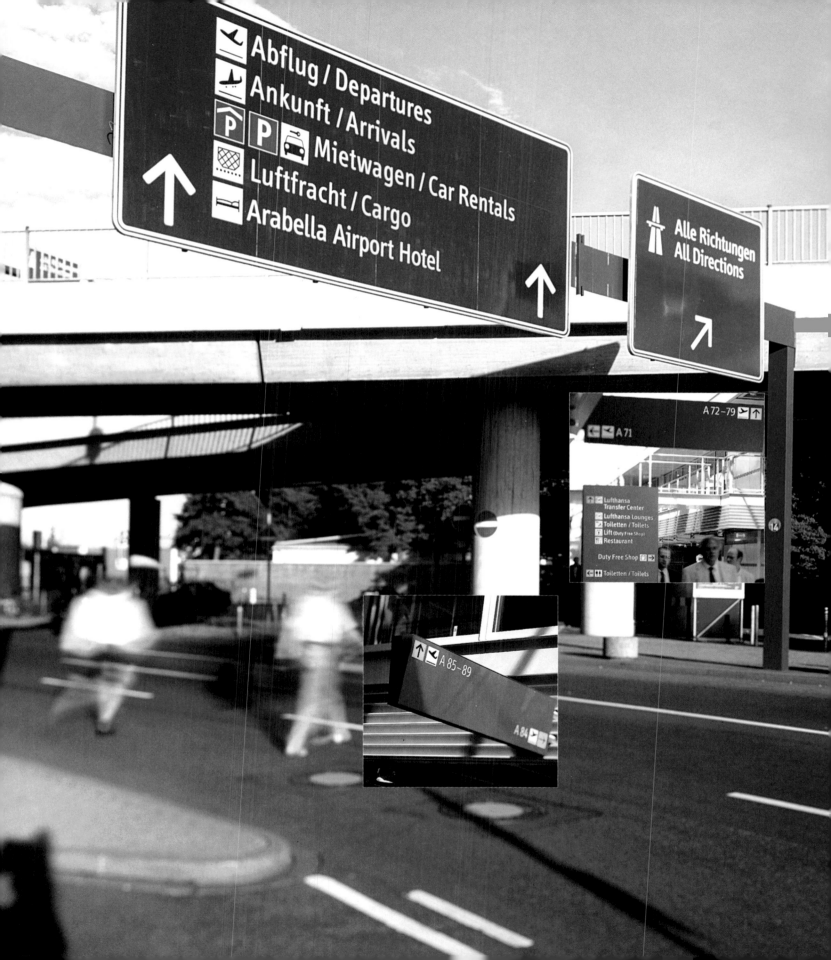

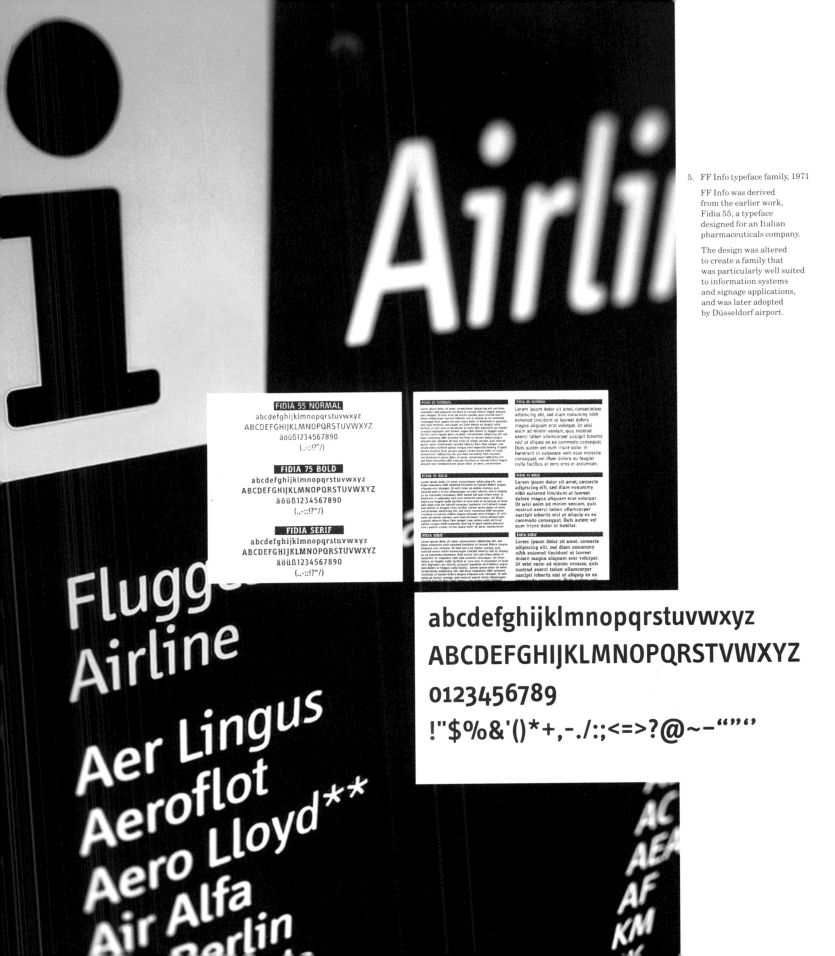

5. FF Info typeface family, 1971

FF Info was derived from the earlier work, Fidia 55, a typeface designed for an Italian pharmaceuticals company.

The design was altered to create a family that was particularly well suited to information systems and signage applications, and was later adopted by Düsseldorf airport.

6. ITC Officina typeface family, 1990–1995

First showing of ITC Officina in the Winter 1990 edition of *U&lc*, the ITC in-house organ.

ITC Officina originally started life in sans and serif forms in just two weights (including italics), with the intention of being a functional family for use in office correspondence. However, as its popularity grew, along with the scope of its usage, it became apparent that the family should be extended to include further weights.

7. Corrections for Officina Black, digitized by Ole Schäfer in 1995

8. Word settings at various weights

6.

8.

ABCDEFGHIJKLMN
OPQRSTUVWXYZ
ÆŒØabcdefghijkl
mnopqrstuvwxyz

Handgloves	Sans Book
Handgloves	Sans Medium
Handgloves	Sans Bold
Handgloves	Sans ExtraBold
Handgloves	Sans Black
Handgloves	Serif Book
Handgloves	Serif Medium
Handgloves	Serif Bold
Handgloves	Serif ExtraBold
Handgloves	Serif Black

9 • Sans Black, 100 pt, 600 dpi

ABCDEFGHIJKLMN
OPQRSTUVWXYZ
ÆŒØabcdefghijkl
mnopqrstuvwxyz

7.

105

9.

BDH
abcdeghil
mnoprstu
145

Deutsche Bundespost

10.

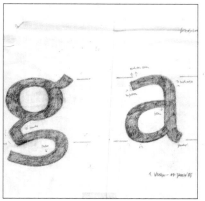

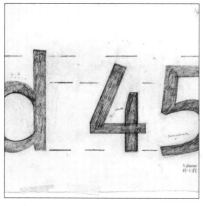

Hamburg
Hamburg

burg
burg

11.

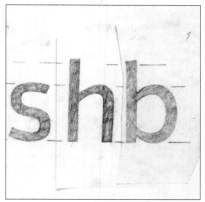

urgloß
PPHfb

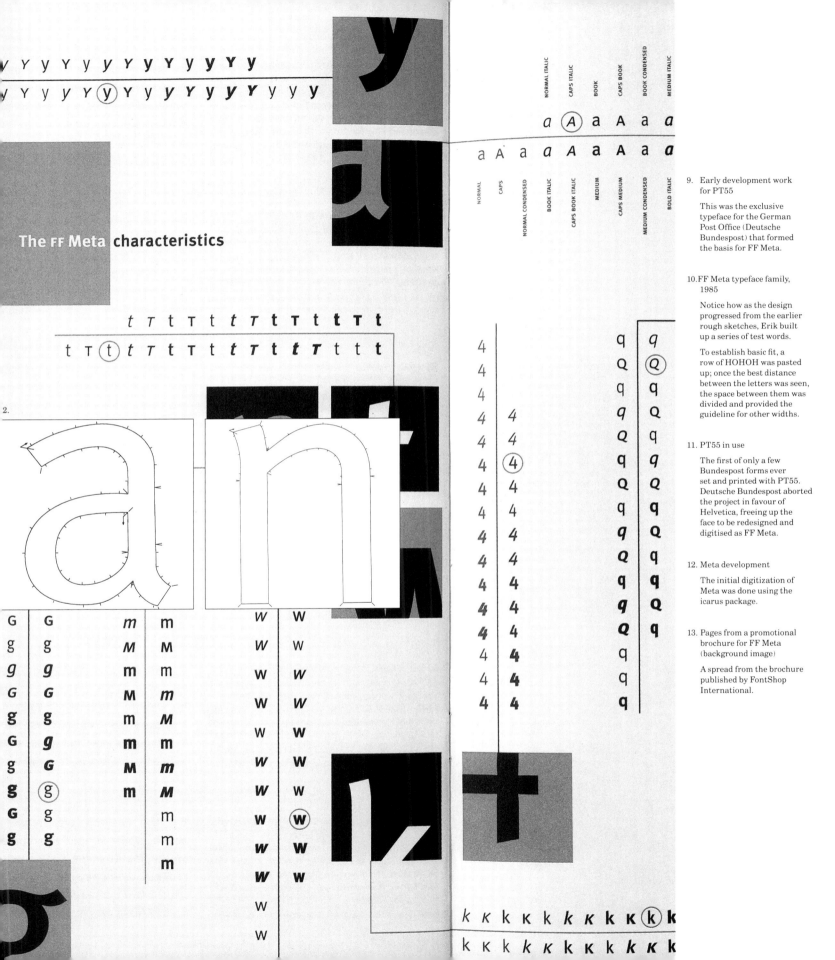

The FF Meta characteristics

NORMAL	CAPS	NORMAL CONDENSED	BOOK ITALIC	CAPS BOOK ITALIC	MEDIUM	CAPS MEDIUM	MEDIUM CONDENSED	BOLD ITALIC

(column headers top row: NORMAL ITALIC, CAPS ITALIC, BOOK, CAPS BOOK, BOOK CONDENSED, MEDIUM ITALIC)

a (A) a a A a *a*

a A a *a* *A* a A a *a*

9. Early development work for PT55

This was the exclusive typeface for the German Post Office (Deutsche Bundespost) that formed the basis for FF Meta.

10. FF Meta typeface family, 1985

Notice how as the design progressed from the earlier rough sketches, Erik built up a series of test words.

To establish basic fit, a row of HOHOH was pasted up; once the best distance between the letters was seen, the space between them was divided and provided the guideline for other widths.

11. PT55 in use

The first of only a few Bundespost forms ever set and printed with PT55. Deutsche Bundespost aborted the project in favour of Helvetica, freeing up the face to be redesigned and digitised as FF Meta.

12. Meta development

The initial digitization of Meta was done using the icarus package.

13. Pages from a promotional brochure for FF Meta (background image)

A spread from the brochure published by FontShop International.

Jeremy Tankard

Jeremy Tankard appears at first glance to be the archetypal modern brand designer. Where the Barnbrooks and Brodys of this world are intent on propagating their ideologies and politics through their work, Tankard's focus is on his client's message – that is, after all, ultimately what we all get paid for.

Stepping into his studio just outside Paddington in London, I was greeted with a wall of books, folders and notepads, neatly arranged and perfectly ordered. As we discussed typography and his work, he would occasionally leap from his seat and from his archives, and pluck out one of his notebooks to illustrate his point, showing his meticulously preserved early development work on his typefaces. Yet beneath the neatly ordered studio and the precision and beauty of his work, lies a man with strong convictions and a passion for design and its place in the world.

A product of Central St Martins and the Royal College of Art in the UK, his interest in typography and typeface design was piqued, as with so many others, by his experimentation with letterpress work. Now an established figure with a global reputation, his first typeface, Disturbance, was originally slated by his lecturers in the RCA as an affront to the alphabet.

His typography – both bespoke identity work and publically-available typefaces – is to be found in work across the globe, respected for combining historical values with modern influences, bound together with precision and attention to detail. He has worked on typography and branding solutions for such high-profile names as BAA, Go (part of British Airways), Goldfish, Heathrow Express, BT, Indesit, Habitat, Iceland, Gameplay and Epsilon.

I asked Jeremy how he got started in typeface design:

"Through the usual routes – I was good at art at school and crap at everything else! I was encouraged by my dad who is in design – publicity, print, exhibitions etc. My school was science and sport focused (as most are in the UK) and art was seen as the easy option, only there to fill gaps in the timetable. Things have changed now, as DTP has made people wake up to design and art is perceived as big business.

"I jumped out of school half way through 'A' levels and went to Lincoln College of Art and Design to do the one-year Foundation course. I was advised by the lecturers at Lincoln to go to Middlesex Uni, but my dad suggested St Martins instead. So I changed my option on the last day and went to Central St Martins to study design for three years, before moving on to the Royal College of Art for their two-year MA. I was interested in type at St Martins but it was the RCA that drove me to focus more on type (letterpress, etc).

"I didn't really enjoy my time at the RCA, as the course felt unfocused. I spent most of my first year in Printmaking and Letterpress to avoid the lectures and tried to produce something different through new media. At the end of the first year I was put on referral to be thrown out. I went to Jocelyn Stevens (the then Rector) and used his might against the course and 'got back in' – as it were. One of my early lessons in 'how to play the game'!

"The second year I focused on doing as much as I could with type. The course wanted me to focus on a certain area – ie; type for advertising etc, whereas I wanted to research type in a wide manner – 'we don't do that here; we have a research fellow' was the basic answer. I was deemed confused and a 'problem with no future direction in graphic design whatsoever – a suitable case for treatment.' (I quote from one of my reports!) All very worrying, to say the least.

"I designed Disturbance for my RCA thesis during the holiday. The lecturers found it 'too disturbing to do this to the alphabet' hence the name! After graduation I redrew the type for FontShop International in 1993. It still needs redrawing – bad curves etc – but it's a legal nightmare to redo it.

"So you could say that the RCA helped me to become tough with idiots – or at least see the 'Emperor's New Clothes' for what they are. Interestingly I was the first student to be employed at the end-of-year show. I went to Addison to work on Sabena Belgian Airlines – and so started a six-year stint in corporate design."

His time at Addison ended when the company ceased trading, then he moved to the brand agency Wolff Olins in London, where he

stayed for several years as their typography guru. I asked Jeremy what motivated him to start up on his own:

"I realised that all I was doing at Wolff Olins and in the corporate world was helping make companies more profit under the fancy-dress of company imaging.

"Yes, business is supposed to make profit at all costs, but it doesn't mean you have to agree with it. The consultants would spend ages 'thinking' about brand values and how to make the employees 'feel' more committed to their companies. Corporate brainwashing? Sorry to sound evangelical or like some kind of anti-capitalist protester, but it wasn't for me. I went into design to do design, to create things of worth, to help make people's lives a little better. This is why I like product design and architecture far more than fashion, art and illustration (yes, graphics too). Products and architecture seem to have a lasting worth.

"I decided that I quite liked the idea of doing my own thing, and if somebody liked it enough to buy it – fine. If I failed, I could always go and get a job again. I liked the idea that a book may be set in my typeface and that somebody may buy that book because they liked the look of it. Or, as with the British Museum now, Bliss enhances an amazing space."

So how does Jeremy approach his typeface design work?

"I start in an A5 sketchbook. I look at the market and its needs and get potential user feedback. As I'm from a corporate-design background, I tend to look for the benefits of 'new' text types that will work to refocus a company and move it forward. I'm not a great admirer of revivals – they are not my thing. Other designers are good at doing their version of Bodoni or Garamond, but I'd rather try to create something 'new' based on the history, etc.

"The notebooks fill up with ideas, research, questions and answers as to why do it, does the world need another..., etc? Then I begin to transfer my sketches to FontStudio. The initial test-characters develop – looking at proportion, colour, structure. I do almost everything in FontStudio, but in the last stages I take the font into FontLab to build the matrix. After importing the kerning from the FontStudio master, I then hint the typeface.

"Once the Mac PostScript FontLabs are done I'll take the Mac FontLab files into the PC version of FontLab and make the TrueTypes – I've started delta hinting them now, so this is done on the PC. Finally, the Mac fonts go through RoboFog to be correctly style-linked.

"To create the PC versions, I use TransType to make the basic PostScript fonts. I then take these converted fonts into FontLab on my PC to rebuild them. I found that this seemed to maintain the fonts' line gaps.

"I spend a great deal of time attempting to make the forms as I want them – the fit, spacing, hinting and finally marketing. I am amazed that some designers can 'do a type in a week' as it takes me a year – I like to enjoy the process! Even though I've been through hell with Bliss recently."

Spending three solid weeks kerning Bliss might well be considered hell by most standards! A family consisting of over 160 typefaces, this major typographic work has been carefully developed over the last decade, covering not just the traditional Western languages but also extensive central European scripts. I asked Tankard about the family's development, and what issues he faced in dealing with such a large, multilingual work:

"When I started Bliss' development, I never intended it to grow into such a large family. I added the fractions at the request of the publishers Thames & Hudson, and a US company commissioned the Extra Light weight (which I retained the right to retail). The central European languages came about due to the expanding and opening up of Europe – I felt that it would prove worthwhile especially for larger, global companies.

"I asked a handful of people about their own language needs, for Polish etc. John Hudson is very good with orthography and pointed out several language and cultural needs that the older, more traditional Western approach neglected.

"Testing and cross-platform compatibility are both problems. The Mac and PC have different code pages for the central European languages – surprise, surprise!"

I finished off our discussion by asking him who has influenced his work, and he cited the work of Bradbury Thompson, W A Dwiggins, Adrian Frutiger, Jan van Krimpen, Gerard Unger and Matthew Carter, but he ended on a personal note:

"Above all my dad – for teaching me many years ago whilst painting at home that 'when you can paint that runner bean green, then you can paint it red,' and for countless discussions about art and design in many pubs over many years."

1. Epsilon identity, 1995

 This brand identity for Epsilon Mediagroup used custom typography to brand its constituent companies in a cohesive way, bringing divergent names together with a common and distinctive visual identity.

2. Gameplay typeface, 1997

 The cross-media nature of this brand identity work required careful typography that would work equally well across high-resolution print, through television and web and down to low-resolution WAP phone. Tankard designed the typeface used for the identity, carefully creating and then refining it using hinting technology that worked well across the various media.

3. Indesit logo, 1997

 The final logo design for the Italian white goods brand, Indesit.

DERBYSHIRE

4. The Shire Types typeface,
 1998–2001

 A set of six typefaces,
 this unusual family of
 interchangeable characters
 was designed to reflect the
 heavy, solid feel of the industrial
 revolution in the Midlands of
 England. Built without
 ascenders or descenders, the
 typefaces all come in either
 uppercase or as unical (mixing
 both upper- and lowercase
 glyphs) fonts, forming a deep,
 heavy tone to any text set in it.

CHESH

worcestershire

FORDSHIRE

warwickshire

WHITCHURCH

st martin's

ELLESMERE

gobowen

selattyn

PREES

market
Drayton

WHittington

OSWESTRY

WEM

HODNET

ruyton-xi-towns

BASCHURCH

NEWPORT

CHURCH aston

LILLESHALL

SHREWSBURY

DONNINGTON

WELLINGTON

SHERIFFHALES

HADLEY

OAKENGATES

Hanwood

Bayston Hill

TELFORD

SHIFNAL

PONTESBURY

MINSTERLEY

IRONBRIDGE

ALBRIGHTON

SHROPSHIRE

BROSELEY

MUCH WENLOCK

CHIRBURY

WORFIELD

CHURCH STRETTON

MORVILLE

SHIPTON

BRIDGNORTH

BISHOPS CASTLE

WISTANSTOW

BURWARTON

ALVELEY

CRAVEN ARMS

HIGHLEY

NEWCASTLE

STOKESAY

CLUN

CLUNGUNFORD

CLEEHILL

CLEOBURY
MORTIMER

LUDLOW

RIVER SEVERN

Heathrow **express**

Emergency exit

FIRST CLAS

5.

5. Heathrow Express
 development, 1992

 The Heathrow Express
 logotype went through a series
 of revisions in its development.
 Here, we can see two early
 versions of the 's' and 'r'.

6. Final usage of Heathrow
 Express trainline identity
 (background and full-page
 images)

7. Heathrow Express identity,
 1992

 While at the London-based
 brand consultancy Wolff Olins,
 Jeremy created this brand
 piece for the Heathrow Express
 train service. The express
 service runs from London
 Paddington station to Heathrow
 in 15 minutes, and it was this
 which was the prime focus for
 the design, while avoiding the
 standard stereotypes in
 representing speed.

7.

Heathrow **express**

abcdefghijklmnopqrstuvwxyz
ABCDEFGHIJKLMNOPQRSTVWXYZ
0123456789
!"$%&'()*+,-./:;<=>?@~—""'' 8.

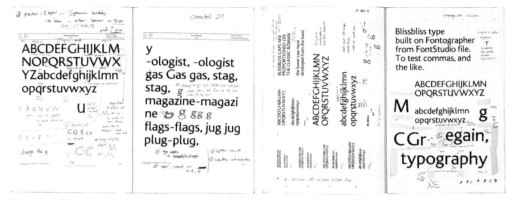

8.

Bliss Light
Bliss Light Italic
Bliss Bold
Bliss Bold Italic
Bliss Caps Light
Bliss Caps Light Italic
Bliss Caps Bold
Bliss Caps Bold Italic
Bliss Regular
Bliss Italic
Bliss Extra Bold
Bliss Extra Bold Italic
Bliss Caps Regular
Bliss Caps Italic
Bliss Caps Extra Bold
Bliss Caps Extra Bold Italic 9.

118

8. Bliss notebooks

During the development of Bliss, Jeremy Tankard kept a series of notebooks which chronicle the typeface's changes. In this spread we can see, in particular, developments to the lowercase 'g'.

9. Bliss Typeface, 1996 – 2001

Bliss is an extensive family of 160 typefaces whose development spans a decade. The typeface originally started life in 1991 and was developed for the following five years before the initial release in 1996. It is one of the most extensive families produced in modern times, covering seven weights and ten languages. It is heavily influenced by the works of Edward Johnston, in particular his belief in creating sans serif typefaces that draw their proportions from Roman square capital letters. Johnston's Underground, along with Eric Gill's Gill Sans, Hans Eduard Meier's Syntax, Adrian Frutiger's Frutiger and the Department of Transport's Transport typefaces all influenced the family's development.

Matthew Carter

"The art of screen font design is really facing up to the fact that it is never going to be perfect... I would look at them and not think either was right; the question is, which is the least bad? You are always making these practical compromises in screen-font design."

This chapter is being written on a computer screen measuring 12.1 inches diagonally, and it displays an image of 1024 pixels by 768 pixels. That's less than 800,000 pixels in total. The printer next to my Mac, into exactly the same space, crams over 200,000,000 pixels.

The difference in resolution is staggering – and completely commonplace – so why do so many people assume that letterforms designed for print can be readily applied to the screen successfully? In many cases, they simply cannot – for example, elegant and delicate serifs of a typeface on paper disintegrate completely or transform into ugly, heavy blocks when translated onto today's low-resolution screens.

As a result, a new form of specialised typeface design has emerged, creating typefaces specifically for use on-screen. The best known example of this is Verdana, a typeface given away free by Microsoft for both its own Windows operating system, and for the Apple Mac. Its designer, Matthew Carter, has over forty years experience in type design, and was steeped in typographic tradition from an early age – his father, Harry, was also an esteemed designer and typographic historian.

After completing his schooling at Charterhouse in the UK in 1955, Matthew was advised by Oxford University to take a year out before beginning his studies in English, thus ensuring he was closer in age to those of his contemporaries who had been conscripted into National Service.

He spoke to me from his studio in Cambridge, Massachusetts, about how this advice ended up cementing his interest in typography:

"My poor parents were faced with trying to find something for me to do for the year and because my father had very friendly relations with the Enschedé printing house in the Netherlands, I went off to spend the year as an intern there. When I arrived in the Autumn of 1955, I started in the type foundry, working alongside Paul Rädisch, their resident punchcutter. Instead of dividing my time between different departments, I ended up spending almost the whole year with Rädisch learning punch cutting. It meant that when my year was up, and it was time to go to Oxford and study English, I simply couldn't face

going back into academic life. I got sufficiently interested in making type that I wanted to stay with that, and rather to my surprise my parents agreed with me. I gradually changed from cutting type to designing it, and when I moved to London in 1959, I started working as a lettering designer."

Carter then moved on to creating custom made-to-order typefaces for customers of Crosfield Electronics' Photon machine, one of the early pioneering phototypesetting machines to come onto the market. This continued until 1965, when he was hired by Mike Parker of Linotype in New York:

"Mike realised there was an opportunity to develop new faces for photocomposition, after most of the metal type library had been converted to film. We planned to consider whether there were any classes of type that had been impossible to make as Linotype matrices, but which might be made as film fonts. Mike hired me as an in-house type designer to develop these new faces for Linofilm. Snell Roundhand was a good example of such a face, a celebration of the fact that you could make a steeply sloped or joining script with the liberating technology of photo composition."

Returning to London in 1971, he continued to work for the British, American and German subsidiaries of Linotype on a freelance basis. However, during the late '70s and early '80s, the market radically changed with the introduction of new digital-imaging techniques (and companies). Policy changed, threatening the extensive typographic development program at Linotype, resulting in four of Mike Parker's team leaving to found Bitstream together:

"We started Bitstream, based on the idea that these new and exciting digital-imaging companies were emerging, and they needed type which they couldn't get from the traditional sources. Bitstream was set up as a source of type to all companies. I spent about 11 years there. Almost all of my time was spent in meetings about sales and marketing and other business issues rather than actually designing. I did, in fact, only produce one new type design, Charter, during my whole time there.

"I found, like many ageing designers, I was spending a lot of time moaning that my life was spent in meetings and not designing. One morning I woke up realising that there was something I could do about this – leave and set up my own design company – so that's what Cherie [Cone] and I did. By 1991 we saw there was enough of a market to sustain a new, small, type foundry, and Carter & Cone was incorporated in 1992."

With this move, Matthew's designs have flourished again, with the release of such typefaces as Miller, Mantinia, Sophia and Big Caslon (his headlining revival of Caslon). Carter & Cone have worked with both Microsoft and Apple on typefaces for inclusion in their respective operating systems. I brought the conversation on to Verdana, asking Matthew about the history of the project:

"It began with someone putting a version of Windows in front of Steve Balmer – and him saying that it looks just like the previous versions, and couldn't we change the font? The previous font was MS Sans, designed by the Windows engineers at Microsoft, which had served them as a system font from the early days.

"No sooner had the idea to produce a new system font for Windows for the menus, dialogue boxes, and so on taken hold, than other departments at Microsoft woke up to the fact that it might be a very good idea for Microsoft to own some typefaces itself for a number of other purposes too. Part of their reasoning was that they had been licensing typefaces from a number of different sources. The Royalty payments were absolutely fabulous – I remember my partner Cherie once opening a cheque from Microsoft and she had to lie down on the floor, such was the pleasant shock she got from such a huge cheque! They decided that they couldn't continue to do that, not because they were stingy, but because the accounting just got so hairy.

"Eventually they had the altruistic idea that by producing a small number of screen-optimised typefaces and giving them away, then they would improve the experience people had in using their applications (and, of course, other people's applications as well)."

The vast majority of TrueType and Postscript typefaces are created using outlines, but when designing Verdana, Carter started by concentrating his efforts on designing the bitmaps first:

"As Verdana was deliberately intended as a screen font, we chose to experiment with bitmaps first of all, trying them on various applications that Microsoft were looking at. We went around and around looking at different bitmaps, weights, styles, sizes and so on. In the end, we managed to get everyone to sign off on a small set of bitmaps, and only when that had happened, did I then go back and wrap the outlines around those bitmaps. Then I gave the outlines to Tom Rickner at Monotype to hint in order to produce the bitmaps that I had originally designed!

"The whole argument for a screen font is that screens are so coarse compared with print. The spatial resolution of monitor screens has barely moved in all this time. Microsoft told me that no one could predict when a high-resolution affordable screen was coming our way – they were up against a physical barrier.

"Microsoft thought it was worth their while to commission a set of fonts with screen legibility in mind. They said we need to grasp the nettle and commission some faces that try and do this, hence all the emphasis on the bitmaps and the outlines being secondary.

"The art of screen-font design is really facing up to the fact that it is never going to be perfect – all the time while working on two versions of a bitmap character, I would look at them and not think either was right, rather than asking, which is the least bad? You are always making these practical compromises in screen-font design.

"I think the virtue of doing the bitmaps first, rather than taking some pre-existing face and trying to fix it with hinting, was that by the time you do get to the outlines, you really have had a very good look at the bitmaps and resigned yourself to the compromises that you had to make, but you have at least had a choice of compromises. You are not saddled with pre-existing metrics from that pre-existing face – you can invent your own."

From cutting punches by hand to placing pixels dot by dot, with virtually all the technologies in-between, Matthew Carter's extensive experiences have inevitably affected his approach to his own work. The last question that I asked him was if this traditional background would be of value to designers entering the profession today:

"I had a traditional training, and I don't regret that, but I know so many young designers who have no background in the traditional aspects of typography at all and I am very open-minded about it.

"If you cut punches in steel, there is a huge penalty for making a mistake – if you worked on a punch all day and at 5pm you make a mistake, you have to start again the following day. Nowadays it's the opposite – computers are so forgiving. If you make a mistake, you just hit 'undo'.

"I have to say, I couldn't be more glad to be working in today's technology – you can be more adventurous nowadays because you can fix your mistakes at very little cost, as opposed to when I was cutting punches where you tended to be very much more conservative in design terms.

"I would not tell my students that they are never going to be good type designers unless they study calligraphy, it's just not true! Get on with type design, use Fontographer, study type design – you may, as a result of that, get interested in cutting letters in stone or calligraphy, then all power to you, but that is not something you have to live through before you can qualify as a type designer. I just don't believe that, and I know too many cases that disprove it."

1. Sophia typeface family, 1993

 The Sophia typeface family was inspired by 6th century letterforms from Constantinople.

The Big Caslon family of typefaces, designed with close reference to William Caslon's originals, were created for use at titling sizes, typically 36pt and above.

54 pt. CAPITALS ABCD EFGHIJJKLMNOP QRSTQUVWXYZ &ÆŒ& SMALL CAPS ABCDEFGHIJJKLMNO PQRSTQUVWXYZ&ÆŒ & figures 1234567890 symbols = @£\$¢¥ƒ© ➤ points.,-–:;·!?ʻ°◇〇□※

lowercase abcdefg 54 pt. hijklmnopqrstuvwxyz ßæœ ligatures ctst fbfffhfifjfkflftffhffifflfft fractions $\frac{1}{4}\frac{1}{2}\frac{3}{4}\frac{1}{2}\frac{1}{4}\frac{3}{8}\frac{5}{8}\frac{7}{8}$ sup1234567890/inf$_{1234567890}$ reference marks ¶§*†‡ accents in caps, small caps & lowercase áàâãäåąçćčďđòćéèêěçèğìíjïîñń òóôöőŏóòfíśşţťúùûüůýyŷÿźżž

22 pt. THE CONCERT room had both an organ and a harpsichord, refreshments on a sideboard, and excellent home-brewed ale. Guests left at twelve, to walk 60 pt. safely home under a full moon. This picture of Caslon's comfortable and cultured domestic life is reflected in his types, or rather in the harmonious smaller sizes it is.

48 pt. THE BIGGER faces are oddly different in style. In his 1734 specimen Caslon showed several titling caps. Some of these were later given lowercases, one being adopted from an older face by Joseph Moxon. Of the sturdy romans that resulted, the two largest are particularly vigorous. Perhaps they were 36 pt. cut by the master himself in a funkier mood, or by William the younger, a chip off the old block, who joined the family foundry in 1742 and later cut a number of gargantuan poster types. Or could they be much older in origin, like Moxon's 17th century face? Caslon's text types, unequalled in legibility, have often been revived; but the display sizes, forceful and a touch eccentric, have had no digital version up till now.

Big Caslon

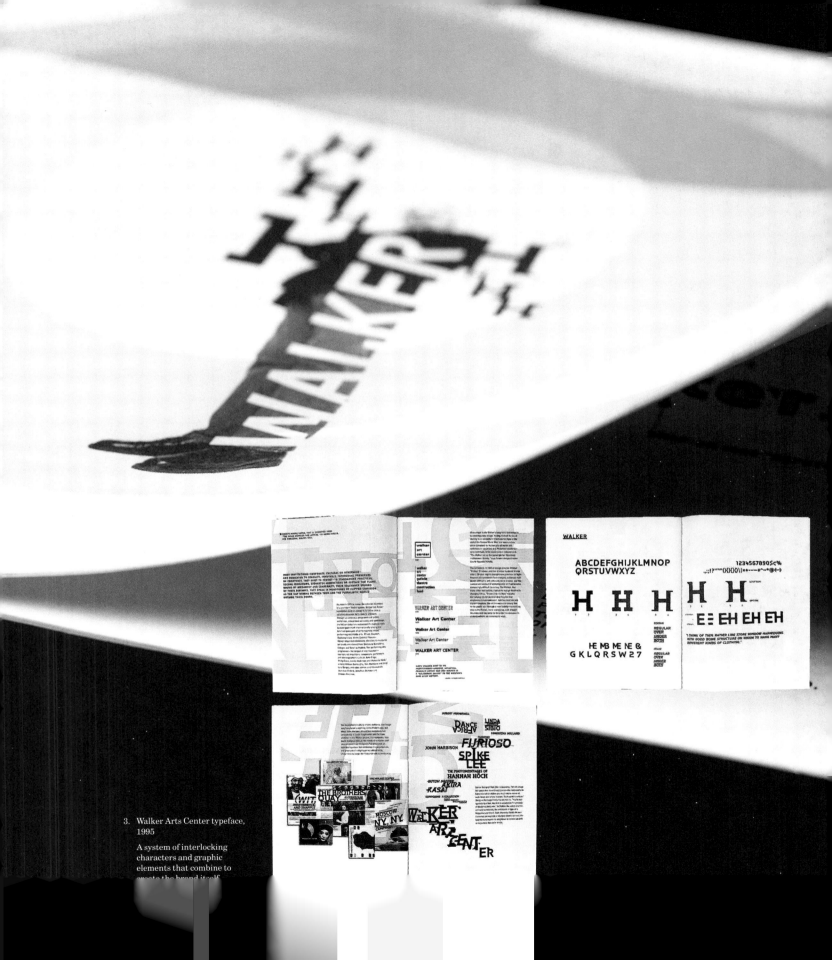

3. Walker Arts Center typeface,
 1995

 A system of interlocking
 characters and graphic
 elements that combine to
 create the brand itself.

4.

A lot of people will just say "don't antialias type below 10pt", or whatever. But its not nearly as simply as that – some faces will look acceptable antialiased at 6pt, while others will lose their legibility at anything lower than 18pt.

Whether a face will antialias well at smaller sizes comes down to three main factors – the face's weight, x-height and the level of detail in the face. Light weights of fonts will antialias into a light grey blur at small sizes – try using a demi-bold or bold version of a face, especially if you're trying to set type at 10pt or lower.

If you're working with faces that have a short x-height or a complex design, they will lose legibility far sooner as you start going down in point size. Any font with delicate serifs or wide ranges of stroke widths is going to suffer badly too.

A final note on increasing legibility at small font sizes – try increasing the tracking – as you go down the size scale, tight fitting type will start to blend into an unreadable blur

Local machine zone

4. Verdana typeface family, 1996

Verdana was commissioned by Microsoft specifically for use on computer screens. The end result, which is installed automatically as part of Apple Mac OS and Microsoft Windows series of operating systems, has significantly increased the readability of on-screen typography, both as part of application programs themselves, and in provision of content on websites.

5. Georgia typeface family, 1996

Matthew Carter also designed Georgia for Microsoft, a serif typeface designed to work well on screen.

4.

abcdefghijklmnopqrstuvwxyz
ABCDEFGHIJKLMNOPQRSTUVWXYZ
0123456789
!"$%&'()*+,-./:;<=>?@~–""''

5.

abcdefghijklmnopqrstuvwxyz
ABCDEFGHIJKLMNOPQRSTUVWXYZ
0123456789
!"$%&'()*+,-./:;<=>?@~–""''

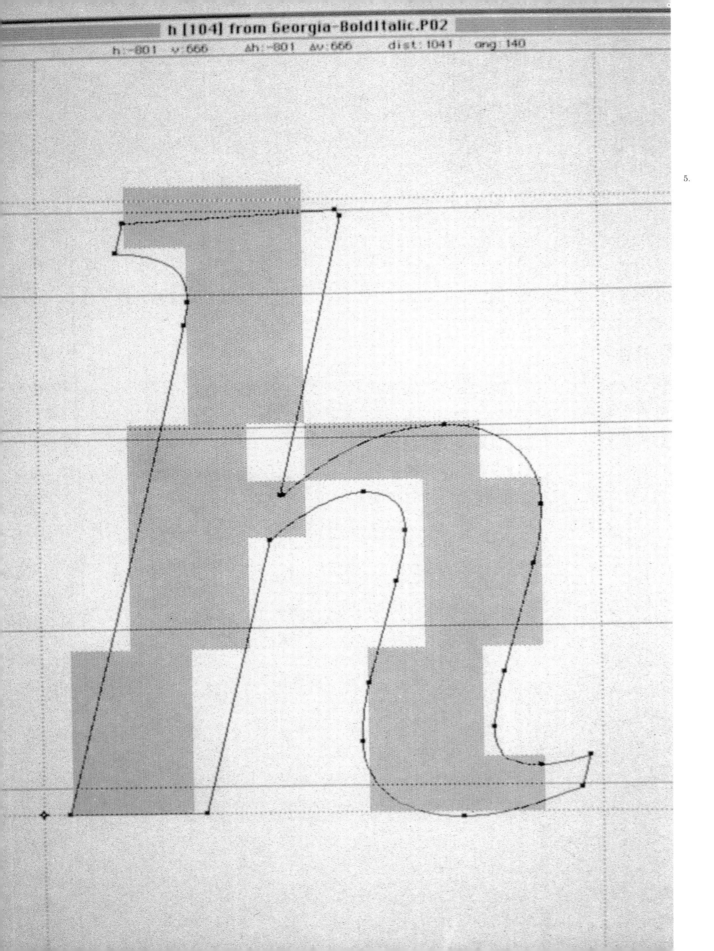

5.

6. Mantinia typeface family, 1993

 The Mantinia family is based
 on inscriptional forms,
 inspired by those painted
 and engraved by Andrea
 Mantegna, the Italian
 Renaissance artist. The family
 is intended for use at display
 sizes, typically 42pt or higher.

SEVENTY-2 PT.
SIXTY 60 POINT
FIFTY-FOUR PT 54
FORTY-EIGHT PT
FORTY-TWO POINT
THIRTY-SIX POINT
THIRTY (30) POINT
TWENTY-4 POINT
TWENTY POINT
EIGHTEEN PT

80-FOUR PT
9TY·SIX PT
108 PT
120 PT
144°

CAPS & SUPERIORS
AABBCCDD
EEFFGGHHIIJJ
KKLLMMNNOOPPQQ
RRSSTTUUVVWWXX
YY&*ZZÆÆŒŒ
FIGURES
1234567890
SMALL CAPS
HACEHIORSTUWYZH
INTERPOINTS ·

TALL CAPITALS
HIHThLHYH
LIGATURES
THVCTHEUPLATIC
TUTWTYMEMPMMBE
ALTERNATIVES
AOT&YRBQQ
ACCENTS &C
ÀÁÂÄÅÆÇĐÈÉÊËIÍ
ÌÎÏÑÒÓÔÕÖÐ
ŠÙÚÛÜÝŻ

ULLMAN THINKS IT WAS POGGIO WHO BEGAN
THE PASSIONATE STUDY OF CLASSICAL INSCRIP-
TIONS TO WHICH SEVERAL GIFTED ITALIANS
DEVOTED THEMSELVES LATER IN THE CENTURY.
SOME OF THEM WERE NOT SCRIBES: CYRIACO OF
ANCONA, ANTIQUARY; ANDREA MANTEGNA,
PAINTER; LEON BATISTA ALBERTI, ARCHITECT;
AND ONE WHO WAS AN ANTIQUARY AND SOME-
THING OF A SCRIBE, FELICE FELICIANO. THEY
WERE CONCERNED WITH REVIVING THESE
LETTERS IN ARCHITECTURE RATHER THAN IN
BOOKS. FELICE'S ENLARGED DRAWINGS OF TY-
PICAL ROMAN CAPITALS BASED ON CLASSICAL
EXAMPLES LED TO A SERIES OF ATTEMPTS TO
CONSTRUCT THE LETTERS BY RIGID GEOMETRY
BEGINNING WITH A BOOKLET BY DAMIANO
MOYLLE OF ABOUT 1480 AND GOING ON LATE
IN THE SIXTEENTH CENTURY. IN WHEREAS THE
CAPITALS OF BLACK LETTER COULD BE & WERE
WRITTEN VARIOUSLY AND DIFFERED FROM
PLACE TO PLACE AND WERE NOT IN THE CHILD-
REN'S ALPHABET-BOOKS, THE HUMANISTIC
SCRIPT WAS TIED TO THE ROMAN CAPITALS AND
WAS INFLUENCED BY THEM INCREASINGLY.

THE LETTERING
OPPOSITE
IS TAKEN FROM
'A VIEW OF EARLY
TYPOGRAPHY'
BY HARRY CARTER
OXFORD 1969
PAGE 66

◆ MANTINIA ◆
TITLING·CAPITALS
were designed to work best for large supplies.
WERE·DESIGNED
by the silk or crown, the surface is built rather literate as
TO·WORK·WELL
well as in the remainder of 'Mantinia' to be lighter
WITH·GALLIARD
They do suffer thirdly and can fit 'Mantinia'
AS·A·TEXT·FACE

◆ COLOPHON ◆
Mantinia was designed by Matthew
Carter and was digitised in Postscript in 1993.
This type specimen was set in digital Mantinia.

The further & freedom given for the adaption in
this script appeared with only faint knowledge of
Mantinia's Galliard. The other grades is to make it the
redrawing will run.

Carter & Cone of Great Typefaces,
Inc. Massachusetts, Pvt. Cambridge the
existent 'telephone' was 942-2662, and all the steps
that our face utter.

NOPQRSTUWXYZ
MCMXCIII
ABCDEFGHIJKLM

MANTINIA™
DESIGNED
CARTER·AND
TO·ANDREA
ARTIST·AND
MANTEGNA
ENGRAVED
EPIGRAPHIC
OF·ANŒNT
REVIVED·BY

A·TYPEFACE
BY·MATTHEW
DEDICATED
MANTEGNA
ANTIQUARY.
PAINTED·&
THE·ROMAN
LETTERING
MONUMENTS
HUMANISTS

Erik van Blokland

The days in which type designers cut punches as a matter of course are now long gone. As the type design community moved from the analogue world into the digital one over the final three decades of the twentieth century, most of its designers did so keeping a step removed from the nuts and bolts of the technology itself. This is, of course, how digital technology should be in the most part for the creative industry as a whole – a transparent tool for the designer to do their job. But, in being so divorced from the technology they use, one could say that designers have lost an important basic understanding of their tools that could aid in the creative process.

Examples of the technology of production influencing the creative process of typography are littered throughout its history. Stonecutters of the Roman Empire working on the Trajan texts knew that, in order to finish a carved line neatly, they needed to incise from either side into the stone. In this way, serifs were born. Metal typographers invented ligatures such as 'fi' and 'fl' to overcome the spacing problems inherent in having a fixed rectangular-shaped metal block for each individual glyph.

An intimate understanding of the technology of production informs the design process, but also opens up new avenues of creative expression that did not previously exist. No better example exists today of such a statement as the work of LettError (www.letterror.com), the Dutch foundry created by Erik van Blokland and Just van Rossum.

I asked Erik how he initially got into type design:

"I studied at the Royal Academy for Fine & Applied Arts in The Hague, in the Graphic & Typographic Design department. At the time Gerrit Noordzij taught type design and got me interested in the field. Just was one year ahead, and Noordzij introduced us because we were both involved in computers, programming, etc. This was around 1987 and at that time, type design was taught without computers, concentrating on drawing, calligraphy, cut-and-paste, photography and so on. Even though we spent a lot of time learning it, practical application of the skills was vague, usually comprising the odd logo or a couple of lines of text. Selling a typeface to a foundry was almost unheard of.

"But when Fontographer, Ikarus et al became available, we (and a lot of Noordzij's students) knew what to do with them – we started making type. Just and I were working at MetaDesign in Berlin (1989–1990); FontShop was next door and they were glad to distribute the fonts we were making.

"LettError started as a small magazine about type and typography at the academy. We kept the name but stopped the magazine, so LettError has been around since 1989."

Erik is now based in The Hague, while Just works from his studio in Haarlem, just outside Amsterdam. I asked how the two collaborate on projects:

"We mostly collaborate on technology, which takes the form of writing code which can be managed by a specialised version of tracking software for programmers. When we need to design something together, usually one of us makes it and the other sees a proof every now and then and comments."

Since founding LettError, the two have embraced technology to such an extent that they not only have a strong collection of innovative typefaces, but are also creating software tools to help themselves and other type designers produce digital typography more efficiently. I asked Erik how important an understanding of the underlying technology behind digital typography is for a designer:

"I'm sure one could make do with a minimal understanding of technology. But life becomes filled with magic and mystery, a lot of mistrust, misunderstanding and frustration. Paradoxically, the more you know about type technology, the less of a factor it becomes. You can deal with it, use it or work around it, but at least you're in control.

"We've taken that one step further with our font application RoboFog – in using it the designer is encouraged to write scripts (small programs) to help in the production, editing, quality assurance, generating, etc of the fonts.

"Even though programming itself seems far removed from design, it can solve a lot of the non-design issues better (for example, you can create a program to 'generate fonts for all files in this folder

and nested folders' or 'list all open paths in each character in all open fonts'). By using a little programming the designer has more time to design."

In creating typefaces, the pair use their own tools extensively. Erik personally uses RoboFog (an application LettError coded, based on an early version of Macromedia's popular Fontographer software), Adobe Illustrator, Python (a scripting language), and a set of his own tools that he has coded himself:

"I can't stand repetitive work, or clumsy procedures just because a tool doesn't do exactly what it should. So my design work is always accompanied by some development work on tools, improving them at the same time.

"Sometimes I start with hand-drawn sketches; then I scan, trace and redraw them on screen. Even though I like rough outlines it still means I have to edit every single point and carefully tune the roughness. Other faces are drawn straight onto screen."

One of the most interesting aspects of the pair's work is the utilisation of technology – usually a clinical, precise medium – to create typefaces that are counter to the usual aesthetic. Rough-hewn typefaces such as LTR Salmiak, or the multilayered typefaces such as LTR Federal (emulating US currency typography) or LTR Bleifrei (based on a hot-metal version of Bodoni) are examples of this. I asked Erik to tell me a little more about his inspiration:

"Typography expresses some sort of human quality. Modern printing and typesetting is so good that it's safe to say that it's just about perfect. 5000 lines per inch, the Hexachrome printing process, carefully tuned fonts. But when you look at the results, the type gets to be really boring. Everything is smoothed out and balanced, standing on the top of Mt. Typography, saying 'Now what?' I like the way sans serif faces were drawn before Miedinger and Frutiger perfected the art."

Their knowledge of the technology has enabled them to take digital typography one step further, however, with typefaces programmed to change with use. FF Kosmik has sets of alternative glyphs that rotate in usage, so that consecutive identical letters such as

one might expect in 'boot' or 'Llanelli' appear differently. FF Beowolf is another example of using programming skills to enhance and experiment with typefaces. Erik explained further about the history of Beowolf:

"We knew that PostScript was a programming language, and that fonts were dictionaries of PostScript code. That was asking for trouble. We experimented with some simple fonts and added code that changed the shapes during printing.

"We started from the technology – we wanted to see it work. Then we built a font with the stuff in it to demonstrate the effects, proving design and programming can be two sides of the same thing."

Designers naturally crave control over their own work, so I asked Erik how anyone can retain a sense of creative control over a typeface design if the font outlines are being randomly changed?

"By determining which factors can be random, and by establishing boundaries for the randomness, for instance stating that a value must be between 0.45 and 0.56. Then you generate a bunch of instances, see if you like the results and tweak the boundaries if necessary. If you find one single value, that's OK: any solution can be a good one. And if you don't, that's good too: you get to see some variation.

"Not all factors in design are suitable for random values. But turn it around: not all factors need to be set in stone either."

With the ability to play so intimately with the mechanics of digital typeface design new possibilities are opened to those willing to experiment and learn the technology. As with all technology, however, there is always the danger of misuse. I concluded by asking if he felt that there was any direct relationship between technology and readability – he thought not, but ended with:

"Without technology there wouldn't be typography at all. But readability happens between the ears, not on paper or on screen."

1. LTR Salmiak typeface family, 2001

 The Salmiak family is the end result of a progression of hand-drawn typefaces produced by van Blokland that extends right back to 1990, with a broad-nibbed pencil-sketched typeface called Oreon.

2. LTR Salmiak Catchwords glyphs, 2001

 The Salmiak family includes Salmiak Catchwords, a typeface comprised entirely of ligatures, logotypes and special characters that give the family an unusually personal touch.

3. Oreon typeface (unpublished), 1990

1.

2.

2.

3. Oreon, unpublished, 1990

abcdefghijklmnopqrstuvwxyz
ABCDEFGHIJKLMNOPQRSTVWXYZ
0123456789
!"$%¢'()*+,-./:;<=>?@˜—""'',

abcdefghijklmnopqrstuvwxyz
ABCDEFGHIJKLMNOPQRSTVWXYZ
0123456789
!"$%¢'()*+,-./:;<=>?@˜—""'',

abcdefghijklmnopqrstuvwxyz
ABCDEFGHIJKLMNOPQRSTVWXYZ
0123456789
!"$%¢'()*+,-./:;<=>?@˜—""'',

4. Critter typeface family,
1996–2001

The successor to an MTV
on-air design, LTR Critter
is designed for low-resolution
usage. The relationship
between the cap height and
the x-height is such that
acronyms inserted into
regular text settings will
not look out of place, without
having to resort to a small-
caps version of the face.

5. FF Beowolf tyeface family,
 1989

 Beowolf is the first typeface
 to have taken advantage of
 the randomisation features
 of the PostScript language.
 Each point on the contours
 of each character is given
 a certain amount of leeway
 in which to move. The result
 is that every single time
 a character is used, it will
 appear slightly different.

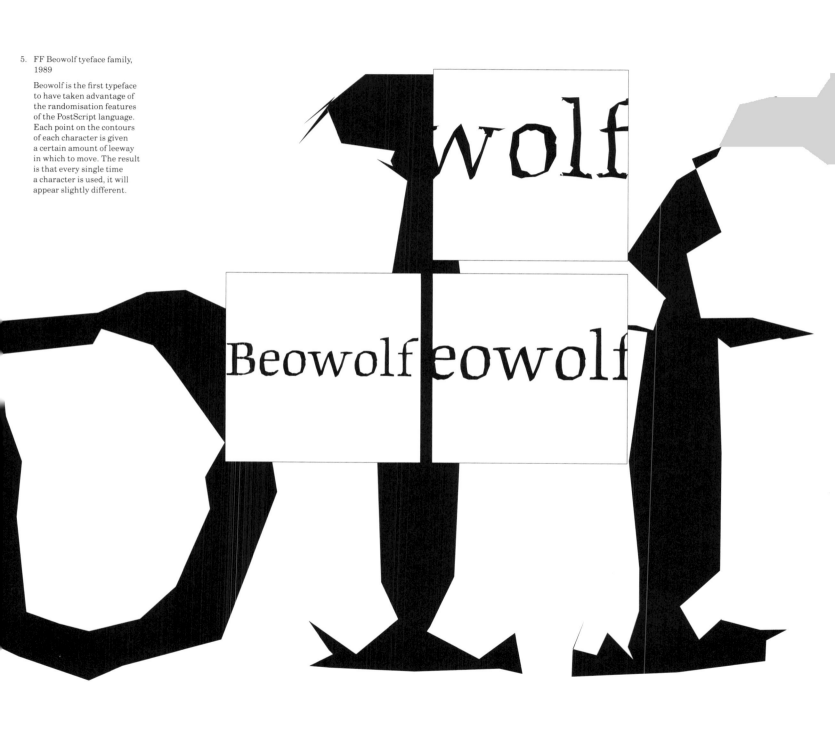

Federal
Federal
Federal
Federal

6. LTR Federal typeface system, 1996

The LTR Federal typeface system is a series of typefaces that, when set in layers, create rich shading effects that simulate engraving. It was inspired by the typefaces used on US currency notes.

abcdefghijklmnopqrstuvwxyz
ABCDEFGHIJKLMNOPQRSTUVWXYZ
0123456789
!"'$%&'()*+,-./:;<=>?@~—""''

abcdefghijklmnopqrstuvwxyz
ABCDEFGHIJKLMNOPQRSTUVWXYZ
0123456789
!"'$%&'()*+,-./:; = ?@~—""''

abcdefghijklmnopqrstuvwxyz
ABCDEFGHIJKLMNOPQRSTVWXYZ
0123456789
!&& () ,-. .;? ˝

7. LTR Bodoni Bleifrei typeface
system, 2001

LTR Bodoni Bleifrei is a set
of three typefaces designed
to emulate a lead type of
Bodoni. The three fonts,
designed to be layered on
top of each other, represent
the slugs, dirt and grime
surrounding the typeface
itself, and finally the imprint
of the typeface proper.

abcdefghijk

ABCDEFG

0123456789

! & & . () - ;; !! ?

8. LayerPlayer, 2000

 For the multi-level typeface systems of LTR Federal and LTR Bodoni, LettError created a special setting application, LayerPlayer, that makes the job of setting the type layers easier.

9. RoboFog software, 1993–2002 (right)

 Using Macromedia Fontographer 3.5 as a base, LettError created RoboFog – a font-editing package that adds a range of features to the original Fontographer code, and allows the entire package to be controlled using the Python programming language.

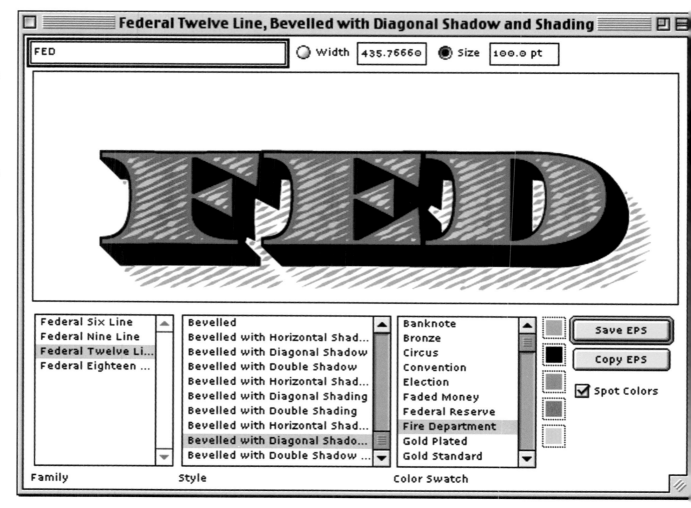

8.

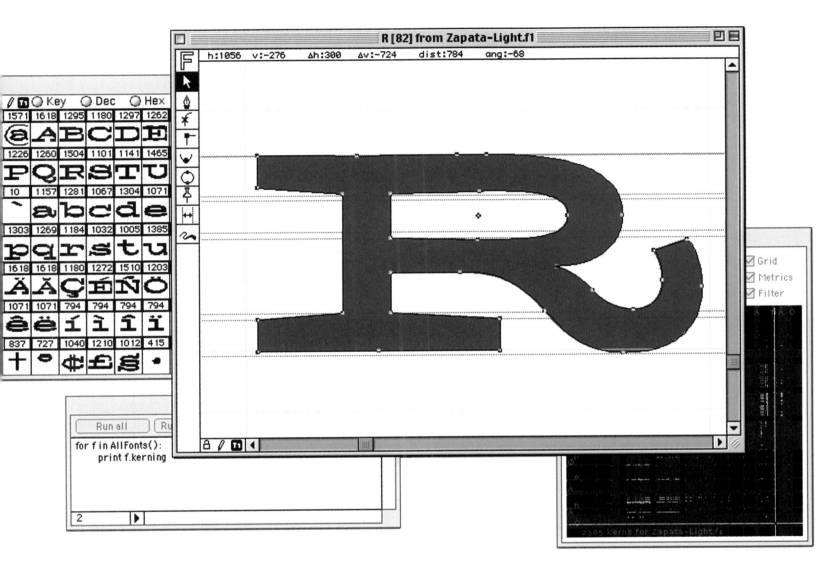

9.

143

Type tutorial

A typeface can come from any number of places. As you have seen from a few of the interviews in the book, it is not always the case that a designer will sit down and think, 'Today, I start work on a typeface'.

Type Tutorial
Starting Off

More likely, you will find yourself being inspired by the visual world around you. You might find yourself idly doodling shapes on a napkin in a restaurant, or you might have an illustration or design brief that requires you to come up with a logotype as part of a branding exercise. It may even just be that you passed by a great old-fashioned sign on your holidays and took a snap of it. Keep examples of type that you create yourself or that you see and find interesting. They may not be right to inspire you for this project, but might prove invaluable in future ones. Remember, though, that while being inspired by other typefaces is a perfectly natural and indeed important part of the type design process, it is never acceptable to copy or plagiarise other people's designs. Copying or modifying existing copyrighted typefaces in a font editor and releasing them as your own is not only illegal, but devaluing and disrespectful of other designers' hard work.

With ideas buzzing around in your head, it is easy to fall into the trap of rushing into a project, but before starting work on a typeface, you do need to pause for thought. Some early planning and thought can save a lot of time down the road. Your first question is simply, "Why am I designing this typeface?" A straightforward question, but one whose answer should end up directing your approach to the entire project.

For example, if you are merely experimenting in typeface design for your own amusement, such as creating a font based on your own handwriting, or a quirky display font you're going to give away for free, then you can pretty much jump straight in and have fun with it.

Wherever you see inspiration, record it, draw it, take photos of it, video it.

If the typeface you are creating is a serious project, intended for extensive use, and one that you intend to charge money for, then it will pay dividends to take your time over it. You will be doing no-one any favours by rushing a project that you and your client or customers will have to live with – this is far truer of typeface design than many of the other graphic arts, as it can be an extraordinarily labour-intensive task to do to a professional standard. Take, for example, the typeface Bliss; in the summer of 2001, Jeremy Tankard, its designer, set aside three solid weeks just to refine its kerning.

Quality isn't just about raw talent; it is also about taking the time to do a job well. This means researching thoroughly what is currently available on the market, working out exactly what the font is to be used for, and what issues you are likely to face along the way. If your beautiful new revivalist serif face is going to be used on everything from the side of an aircraft to business stationery, to a handheld computer, you need to know this at the start. It can also be helpful to know what other people have done to solve particular problems in the past – you can learn from them, just don't copy them!

Build up a body of experience, read books on the history of type, on the work of type designers old and new. Visit the library and find out all you can, especially if you have specialist resources in your area. Spending a few hours at a place such as St Brides Printing Library in London, for example, will teach you more about typefaces, their tactile qualities, and their construction, and the experience will be worth more than a hundred books like the one you have in your hands right now.

So, you have your ideas and are ready to start. Before you do, it is always a good idea to set yourself a brief for the typeface. Describing the project to yourself like this will make sure you know exactly what the typeface is meant to be about, and can help you stay on track.

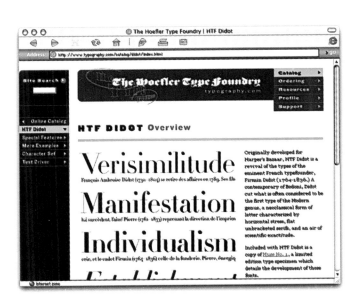

Every craftsman requires a set of appropriate tools for the job, and type design is no exception. Your tools, however, are very much reliant on your own personal methods of working.

The Tools

As we have seen through the interviews, some designers prefer to work almost exclusively digitally, designing their typefaces in an illustration package and building the resulting fonts in a type-editing package. Others prefer to work on paper extensively before moving on to the computer.

What your tools are also depends on the style of typeface you are creating. For example, if you are creating a typeface based on marker-pen writing, it does make sense to use a marker pen to draw the typeface on paper, then scan in the artwork and work from there. However, for geometric, precise fonts, one could argue that a computer is a better place to start. As a general rule of thumb, though, the following equipment is a good starting point.

1. Sketchbook

The first place to start is a sketchbook – get a good quality book to experiment with. Preliminary sketches, even if incredibly rough, can help you to focus your thoughts during the early stages and help you avoid making mistakes early on.

2. A scanner

This need not be expensive or particularly high resolution, but a scanner can come in very handy for getting glyphs into your computer. This is especially true if you are working on a typeface that has a hand-drawn or manipulated feel to it, such as handwriting fonts.

3. Illustration software

Using a dedicated vector drawing package to create your outlines will give you greater flexibility and control. This is Adobe Illustrator at work.

Most designers will not want to work directly in the font-editing software to draw or edit glyphs – the tools are often basic and will not offer the flexibility of a dedicated illustration package. Adobe Illustrator and Macromedia Freehand are both good choices, but others will often do just as well, providing they can output EPS files so you can bring the glyphs into the font-editing package.

If you find yourself using a lot of scanned images in your typeface design, it might be worth getting a specialised tracing package, such as Adobe Streamline, that will give you greater control and better results when tracing bitmapped scans into vector format.

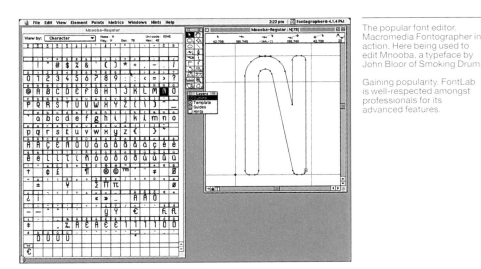

The popular font editor, Macromedia Fontographer in action. Here being used to edit Mnooba, a typeface by John Bloor of Smoking Drum.

Gaining popularity, FontLab is well-respected amongst professionals for its advanced features.

The most important element – once you have designed your glyphs – is an editing package to actually build them into a working font that you can install on a computer and type with.

There are two main options here; FontLab or Macromedia's Fontographer. Both are available for Windows and Macintosh computers, and both have their respective proponents.

Macromedia's Fontographer is certainly the most popular package currently being produced. A complete package with support for advanced features, it is also slightly cheaper than FontLab, and the large number of users out there may make it easier for new users to get help from support groups. You should be aware, however, that at the time of writing (2002) it has not been updated in over eight years, so as operating systems and font technologies advance it is slowly becoming increasingly incompatible with them.

FontLab, by the company of the same name, is seen as the more technically-advanced editor and supports such high-level features as OpenType and the ability to edit Japanese character sets (thousands of characters). It has been actively supported by its Russian developers since its release, and is gaining popularity among professionals, although it can be trickier to get to grips with than Fontographer.

There is also a cut-down version of FontLab available called TypeTool that has some of the more complex features such as the ability to create Multiple Master fonts (see glossary), making it a good option for those wishing to dip their toe in the type-design waters.

You have your inspiration and ideas, you've done your research and now your tools are set up. Let's start.

The Basics

It is entirely up to you whether you work exclusively on computer or on paper. Try and take your cue for this decision from the typeface itself, and the benefits and constraints of the medium you choose. For example, for a handwriting font, it makes sense to draw it by hand and scan the resulting image into your computer. For a font that relies heavily on geometry and physical accuracy, it makes sense to use a computer from the outset, as the computer tends to lend itself well to such forms.

Remember to include a plan of the full extent of what you want to achieve. Is this going to be a one-off typeface, or a family of them, in different weights, styles, languages, etc? At the very least, you should decide which characters you are going to include at the start. This will help you develop the typeface style as a whole and maintain consistency throughout each glyph.

No Red Food is a font based on the handwriting of Faye Greenwood, a London-based graphic designer. She provided a sample of her handwriting on paper, which was then scanned in black and white at 1200dpi, providing a decent level of detail from which to start before being taken into Adobe Photoshop to be cleaned up.

Let's take the typeface No Red Food as an example. Faye, on whose handwriting it is based, was given a form to fill in that covered all of the characters to be included in the typeface, thus allowing me to sample her handwriting in one sitting. Why would this be important? People's moods and environments change. On a cold day she may have written more slowly, on a day when she was rushing around trying to please clients, she may have written more haphazardly and quickly. This is an extreme example, admittedly, but the same will hold true of most typeface styles and genres – you should never have to return to a typeface months after its first release to add characters that are crucial to the design.

Ensuring your typeface has a full complement of characters will also become important should you wish to submit your work to a foundry for inclusion in their portfolio. If you intend to release your typeface through a third-party foundry, you should be aware that many will insist on including a certain range of characters, and this will depend on the typeface and the foundry's own guidelines. Be sure to check these out early on so you are not left retrofitting additional glyphs at a later stage.

When it comes to drawing the individual characters (no matter if it is on paper or on screen), start off by creating just a representative series of characters – an industry favourite is 'Hamburgefonts' or 'Hamburgefontsiv'. The selection of letters used allows you to experiment with the general forms of the letters, including the ascenders and descenders, character widths and how the upper- and lowercases relate to each other, without going too deeply into a character set. I prefer the latter option, as the extra two characters give you a chance to deal with diagonally stroked glyphs such as 'k', 'v', 'w', 'x' and 'y', and characters with satellites, such as 'i', 'j', 'é', 'ü', and so on.

A B C D E F G H I J K L M N O P Q R S T V W X Y Z
Æ Œ À Á Â Ä Ã Å Ç È É Ê Ë Ì Í Ï Î Ñ Ò Ó Ô Ö Ø Ù Ú Û Ü Ÿ
a b c d e f g h i j k l m n o p q r s t u v w x y z @
æ œ fi fl ß à á â ä ã å ç è é ê ë ı ì í î ï ñ ò ó ô ö õ ø ù ú û ü ÿ
& # $ 0 1 2 3 4 5 6 7 8 9 ¢ £ ¥ % ‰ + = { ([]) } * ¶ † ƒ
© ® ™ ª º , . … : ; ¿ ? ¡ ! _ ' " " " ' ' „ / • - – —

This is a typical full character set for a professionally-released typeface.

Freehand and Illustrator can both autotrace bitmapped scans. In this Freehand screenshot we can see the raw tracing on the left, and the editing process on the right. On a technical note, you should never apply a stroke of any kind to your curves; they will just be ignored by most font editors when you import the glyph.

Refining this small selection will help you gain a far better feeling for how the characters relate to one another, and will also help you make decisions relating to individual glyphs as you move on to the rest of the character set.

As your character set grows, it is important to keep referring back to previous characters to maintain consistency and the feel of the typeface. Keeping the weight of each glyph consistent – its line widths and angles – is particularly important. You may find it useful to overlay characters on top of each other from time to time to help you judge this.

Finally, as your work becomes more and more computer-based, remember to take regular back-ups and keep them safe. At this stage, as you painstakingly edit each of the glyphs, you will be getting a feel for just how labour-intensive creating a typeface is – disasters may be unavoidable but a little foresight and time spent making back-ups can save a lot of frustration should the worst happen.

When to move your designs into a font editor to begin building will depend on your own personal preferences. In the case of No Red Food, I decided to edit all the traced glyphs in Freehand before importing them as EPSs, one by one, into TypeTool.

Building and Refining

As you bring each glyph into the font editor, check the curves carefully to make sure they have imported correctly – sometimes errors can creep in and you may need to tweak them within the font editor. This is particularly important as some editors use a different method of describing a curve than those used in PostScript (technically, TrueType uses quadratic splines, whereas PostScript fonts use cubic Bézier curves, so if you import EPS data into an editor that uses TrueType's method of describing a curve, it will have to convert them). As you bring them in, it's a good idea to print each glyph again, just to make sure that any very small errors are spotted early on.

Along with ensuring that the imported glyphs are the correct size in proportion to one another, you also need to make sure they sit correctly along the baseline. Remember, though, that this does not necessarily mean that those glyphs without descenders should sit precisely on the line itself – in most types of fonts, some characters, such as the 'C' or 'O', may need to sit very slightly below the baseline to be optically balanced.

Each glyph should have space on either side of it to separate it from those adjacent glyphs in a word. This part of the glyph, referred to as the 'sidebearing', should be allocated to each glyph individually and not just assumed to be the same for all of your glyphs (incidentally, the wholeprocess is referred to as letterspacing). Just as positioning your glyphs on the baseline requires you to judge how it balances optically, keeping the letterspacing looking consistent does not equate to making all the sidebearings the same size. You will need to adjust each glyph's sidebearings individually and test them with other character combinations – setting blocks of text and printing them can help enormously with this. Simply mark any problem characters. It is important to remember that the sidebearings need to be judged on a global basis; that is, averaging out how well the spacing works across a wide variety of character combinations.

There will be some combinations of glyphs that, no matter how carefully you have set up your sidebearings, will simply never space satisfactorily. Because of the shape of certain glyphs, some pairings, such as 'To' and 'Av', will end up with ugly unintentional spaces between the letters, requiring special treatment called kerning. If you imagine a glyph (complete with its sidebearings) to be placed in a box, then kerning is simply bringing the two glyphs together and allowing the boxes to overlap, thus removing the unwanted space.

Preview/Metrics – No Red Food

Kerning ◆ ‡A 128 ◆ NO RED FOOD ◆

Pairs #1 Kerning: 21 ⬍

587 472 282 424 472 564 282 465 472 472 564

NO RED FOOD

A font may have a few hundred kerning pairs, each of which has to be carefully edited by hand. Font editors can help with this process, by automatically kerning a typeface for you, but the results will never be as good as those that can be achieved by taking the time to do it yourself. Yet again, your eye will produce a better result than mere mathematics or algorithms. A good approach is to let the font editor automatically kern the typeface for you, then fine-tune the font by editing the pairs by hand. The font editor will typically have a special window to allow you to edit sets of kerning pairs, often allowing you to drag around the glyphs, moving them closer or further away. While having a selection of glyphs on screen to do this is certainly useful, you should still print blocks of text with your font at different sizes to check them on paper. This real-world context will help you to spot slight imperfections that may not be so readily visible on a computer screen.

The success of a typeface relies as much on the spacing between and around characters and words as the curves of the glyph itself. Although carefully adjusting the sidebearings and kerning pairs of a typeface is a painstaking and long process, they are vital elements in creating a typeface. Quite simply, if you want to create a good font, you need to take the time to do the job properly.

Both Fontographer and the FontLab series will do a reasonable job at automatically kerning your fonts, but you should still fine-tune the end results carefully. Here, I am ajdusting the 'OD' pairing.

With the building of the typeface complete, your next stage is to export your design as a working font. When this time comes, you will need to decide which font formats and platforms to support. The main two font formats supported by Apple Macintosh, Microsoft Windows and the various flavours of Linux are the TrueType (developed by Apple and Microsoft) and Postscript Type 1 (developed by Adobe). TrueType fonts are easy to deal with and are commonplace with consumers, having the advantage of being easily installed without requiring much knowledge on the part of the user.

Postscript fonts are perceived to be of higher quality (though this is debatable) and are favoured by designers and output bureaux. They are, however, trickier for the end user to work with and some versions of the MacOS and Windows operating systems may need additional software (Adobe ATM) to render the fonts on-screen adequately. Postscript fonts also place a requirement for you to create bitmap versions for use on-screen – font editors will do this job for you, but the end results can often be less than satisfying, requiring extensive editing afterwards.

Finally, it is a wise idea to create both Macintosh and Windows versions of your typefaces for distribution. This will ensure that your fonts will work on virtually all desktop computers.

With a completed typeface on your hard disk, it's tempting to send it out there and then to friends or post it on your homepage, but there is one final, but vital stage before the font is ready to be released. Testing is dull, but of immense importance – your reputation is in your hands alone, so carefully and methodically check your typeface for technical and visual errors. That means printing comprehensive test strings on as many devices as possible, including high-end professional devices such as imagesetters at reprographics houses. It means printing your characters large and small to see how well they stand up to close inspection. You also need to make sure that all the glyphs are in the right place and encoded appropriately for the target language. Making mistakes is only natural and easily done, but rectifying them after they have gone to third parties is often a nightmare.

After the characters have been imported into TransType, they are checked and edited. Here, the letter 'S' is being adjusted to be slightly heavier, making it more consistent with the other glyphs.

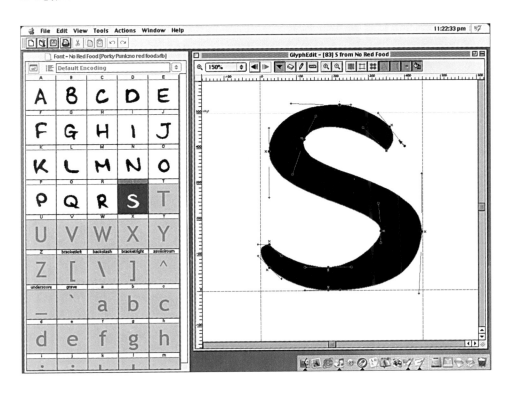

With a completed typeface on your hard disk, your next step is to decide on exactly how to distribute it.

Releasing

The most basic decision you will have to make will be whether to try to get an established type foundry to distribute your work, or whether to go it alone and start your own type foundry.

The traditional method is to submit your typeface to a set of established type foundries, such as Monotype, Bitstream, ITC, Adobe, [T-26], and so on. The advantage with this is that if accepted, you do not need to worry about the marketing and distribution side of selling a typeface – they will do all that for you; producing specimens, advertising, fulfilment, etc. You will also gain a certain amount of instant credibility if you get one of the well-respected foundries to take up your work, which can be of particular use in the early stages of your career.

Taking the traditional foundry route to market your work has much to offer, but there is a price to pay, literally, creatively and in terms of control of your work. Typically, you may only end up receiving around the 20 percent mark in Royalty payments, meaning you will only see £10 of a £50 typeface. Many foundries will also place curbs on that typeface, such as requiring that they be sole distributor of that work, and possibly insisting on options on future typefaces within the same family. Finally, commercial type foundries are businesses, and you may find that they may be less well disposed to designs that are experimental, as they may well be harder to sell.

The emergence of the internet has resulted in a democratisation of type distribution and marketing. New independent foundries can rival the big established names on equal terms on the web.

The alternative, of course, is to create your own type foundry – you get to control exactly how your work is distributed, from its price, to the advertising, its license details and so on... At first, this may seem daunting, but it is not nearly as frightening as it first appears. The advent of the web has made this option a reality for many, with 'microfoundries' springing up across the world. These include such established examples as Jonathan Hoefler's Hoefler Type Foundry and Jonathan Barnbrook's Virus.

Remember that you can choose at what scale you want to work – for example, you may just want to release a few freeware or shareware typefaces for download via a website – a fairly simple and inexpensive process. Many of the new emerging type designers have initially started off in this way before moving on to create commercial foundries – a good example of this evolutionary approach is Ben Balvanz's Fontalicious foundry.

A commercial foundry is a slightly more complex affair; running a commercial concern will require you getting your hands dirty in accounts, arranging professional payment processing, fulfilling orders and marketing your fonts beyond just producing a website. As a result of all that hard work, you will receive a far larger percentage of the end price along with complete control of your work.

No matter which route you take, before releasing any typeface you need to ensure that you protect your intellectual property rights. If you are releasing your typefaces through a third-party foundry, check through the contract carefully, ideally with professional legal advice. Make sure that any rights you give up to the distribution or even copyright are very carefully considered before you sign them away – bear in mind that it is inevitable that some restrictions will be placed on you, but be sure that they are fair and they do not hinder your future work unduly.

If you decide to go it alone and distribute fonts yourself through your own type foundry, you should ensure your work is legally covered by not only your country's copyright and trademark laws, but also by an end-user license agreement. These can be particularly thorny issues as intellectual property laws differ from country to country – again, taking specialist legal advice is the best course of action. Detailed discussion of intellectual property in relation to typefaces is beyond the scope of this tutorial, but you can read more by visiting the website of TypeRight (http://www.typeright.org/), an organisation set up and run by type designers themselves to promote and educate on the legal issues involved.

Finally, before taking the final steps towards releasing your work, be absolutely sure to check that they meet a genuinely high standard – your reputation, and potentially your livelihood, may end up depending on it. Good luck!

Glossary

Arm
Horizontal or upwardly sloping strokes (that is, upwardly from left to right), such as you would find in the characters 'T' and 'K'.

Ascender
The part of a lowercase character that goes above the x-height in characters such as 'h', 't' and 'i'.

Bar (also crossbar)
A horizontal stroke that links two vertical strokes, such as one might find in the character 'H'.

Baseline
The implied horizontal line upon which characters sit.

Bowl
A completely enclosed white space created by a stroke in characters such as 'g', 'o' and 'q'. Note that all bowls are counters, but not all counters are bowls. Also note that, in a lowercase 'g' where there are two bowls (such as the one on the cover of this book), the lower one is called a loop.

Bracketed serif (also adnate)
A smooth curved transition from the main stroke or stem of a character to its serif.

Cap height
The average height of an uppercase character in a typeface.

Counter
A partially or fully enclosed white space created by a stroke in characters such as 'c', 's', 'g'.

Descender
The part of a lowercase character that descends below the baseline in characters such as 'g', 'j' and 'q'.

Hair serif
Thin, fine serifs, such as those found on Bodoni.

Hinting
The process of altering the shape of a font's outline to create a more acceptable rendering on a computer screen. Because of the low resolution of computer screens when compared with print, subtle details of a glyph can be lost (such as the serifs), and lines may become broken. Hinting a typeface remedies this when a typeface is displayed on a computer screen.

Kerning
Certain pairs of letters do not sit comfortably next to each other and create ugly wide spacing anomalies in type settings. Two typical examples are the pairings of 'To' and 'Av'. Kerning is the process of moving pairs closer together to eliminate these spacing anomalies, such as bringing the 'T' and 'o' closer together so that the 'o' sits slightly under the bar of the 'T'.

Letter spacing (also tracking)
The overall spacing between letters on a line of set type. Not to be confused with kerning.

Ligature
Two or more glyphs that are formed to create a single character, such as 'fi', 'fl', 'ffi', etc. They exist to create a more pleasing balanced setting of characters that might otherwise overlap awkwardly – for example, the overhang of an 'f' interfering with the dot on an 'i'.

Light shatter
On back-lit signage, the refractions caused by the prismatic effects inherent in sharp corners.

Ornaments
Purely decorative glyphs that do not serve a textual purpose.

Phototypesetting
A system of setting type that projects light through transparent matrices (negative or positive films of the glyphs) onto a photo-sensitive surface.

Rubylith
A transparent red, slightly adhesive masking film designed to be cut with a sharp scalpel or craft knife. The film is photographically opaque, so it can be used to mask areas of photographic paper before being exposed to light to create images from the unmasked areas.

Sanserif (also sans serif, unserifed, grotesque)
A typeface without serifs, such as the Helvetica and Gill Sans typefaces.

Serif
A small additional line added to the start or end of a stem or stroke on a glyph.

Slab serif (also Eyptian)
A serif of the same width as the main strokes of the glyph, such as those found on the Rockwell and Clarendon typefaces.

Stem
A major (or principal) vertical (or nearly vertical) stroke, such as the two vertical strokes found in 'H'.

Stroke
Common usage simply defines this as any major line, but to be completely accurate, it is the main diagonal part of a glyph, such as one might find in an 'N' or 'X'.

Swash
A stroke of a glyph (usually uppercase) that will extend far and beyond what one would usually expect of a typeface; often used to create a more decorative type setting. For example, the tail of a 'Q' might extend beneath the baseline and to the right for several characters, flowing underneath them. Due to the often cursive nature of swashes, they are usually found in italic typefaces.

Tail
The downward sloping strokes found on the characters 'R' and 'K', and most prominently, the 'Q'.

Unbracketed serif (also abrupt)
Serifs without brackets – the serif will break suddenly from the stroke or stem at an angle.

Wedge serif
Straight-edged, angular-shaped serifs, not dissimilar to triangles, such as those found on Matrix.

X-height
The average height of a lowercase character in a typeface, excluding any ascenders or descenders. Named, rather predictably, after the height of the character 'x'.

Contacts

Jonathan Hoefler
hoefler@typography.com
www.typography.com

Jonathan Barnbrook
virus@easynet.co.uk
www.virusfonts.com

Akira Kobayashi
akobayashi@linotypelibrary.com
www.linotypelibrary.com

Zuzana Licko
zlicko@emigre.com
www.emigre.com

Jean-Françoise Porchez
jfp@porcheztypo.com
www.porcheztypo.com

Rian Hughes
rianhughes@aol.com
www.devicefonts.co.uk

Carlos Segura
carlos@t26.com
www.t26.com

Erik Spiekermann
erik@spiekermann.com
www.spiekermann.com

Jeremy Tankard
jtankard@typography.net
www.typography.net

Matthew Carter
carterm@concentric.net

Erik van Blokland
erik@letterror.com
www.letterror.com

Acknowledgements

A big thank you to all the designers who were kind enough to contribute their words and work to the book. Without their generosity in time and effort, the book would never have happened. Warmest regards to Kate, my editor, who did a sterling job in not having me brutally murdered.

Special thanks go to Doug, who had to endure more than his fair share of my grumpy moods, and managed to hug me out of most of them. And to Tom Scut, for his uniquely pleasing perspective, and for reminding me that there is a whole world out there that, amazingly, doesn't involve typography.

To Marie, Martin, Karl, James, Carlos, Farkie, Todd, both Matts, Faye, Steve, Stu, Rebecca, John, Lonneke, my thanks for being supportive. Thank you to Robert Bringhurst, Dean Allen, George Monbiot, John Vidal and Stephen Fry for demonstrating the joy in writing through their work on paper and screen.

For fuelling many nights in front of my Macintosh, a thank you to NoFX, [Spunge], Fugazi, REM, Crass, Less Than Jake, Mighty Mighty Bosstones, Buck o Nine, Capdown and Green Day.

Finally, thank you to Eric Gill for igniting the passion in me in the first place.